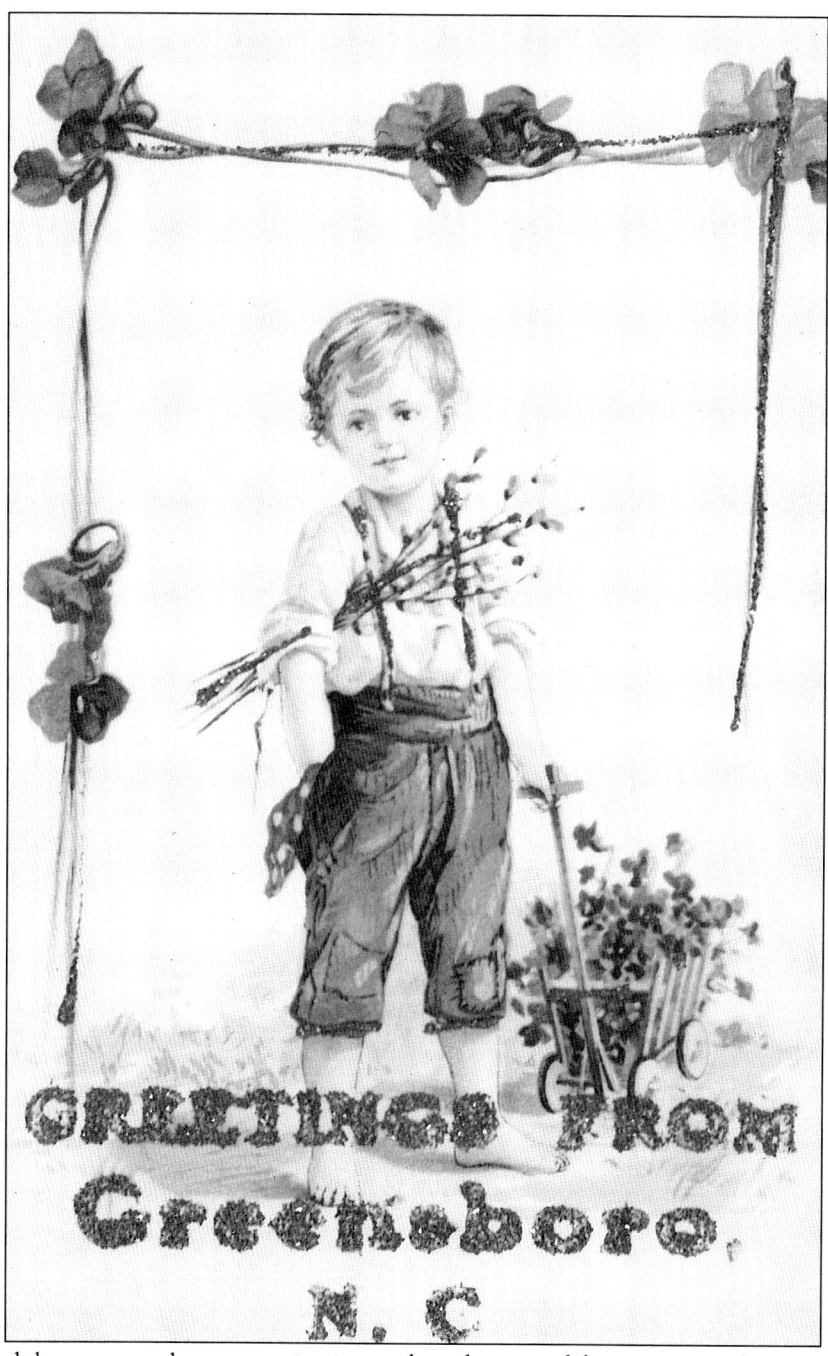

Postcards became popular communication tools at the turn of the century, and a message could also serve as an attractive souvenir. Cards were printed with appealing drawings of children, animals, and flowers, with photographs of street scenes, important buildings, and events, and with advertisements and humorous sayings. Before 1907, postcards sent in the United States had the image and message on one side with the address on the reverse. This "Greetings from Greensboro" card, tinted with gilt lettering, is one of 18 used in this book. It is one of approximately 250 local postcards in the museum archives.

IMAGES of America
GREENSBORO
VOLUME II
NEIGHBORHOODS

Gayle Hicks Fripp

Copyright © 1998 by Gayle Hicks Fripp
ISBN 978-0-7385-6882-9

Published by Arcadia Publishing
Charleston, South Carolina

Printed in the United States of America

Library of Congress Catalog Card Number: 98-88699

For all general information contact Arcadia Publishing at:
Telephone 843-853-2070
Fax 843-853-0044
E-Mail sales@arcadiapublishing.com
For customer service and orders:
Toll-Free 1-888-313-2665

Visit us on the Internet at www.arcadiapublishing.com

*This book is dedicated to all good neighbors
and to preservationists who value their communities.*

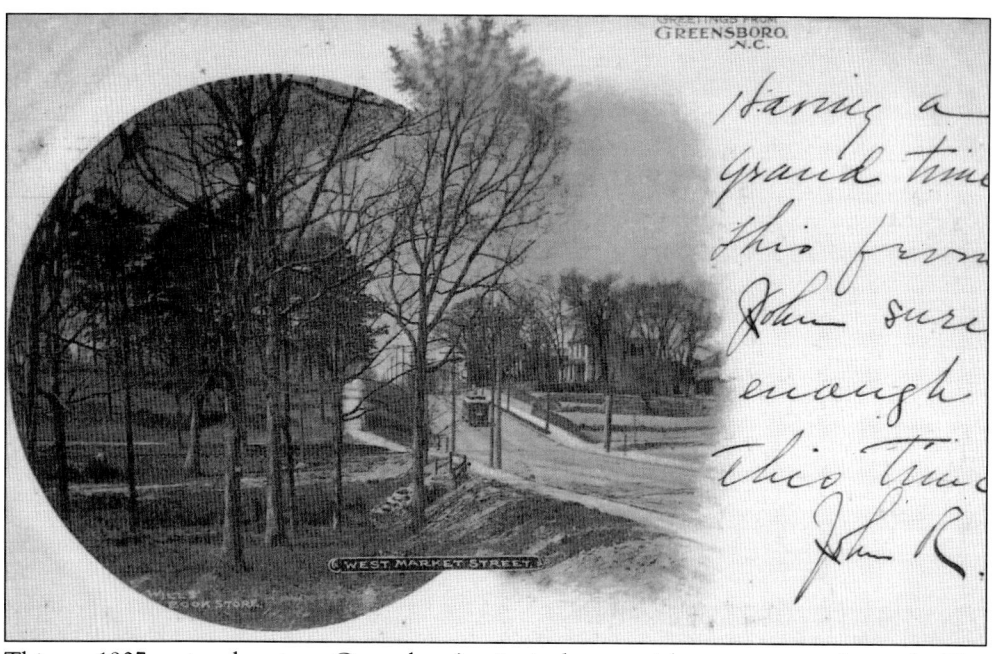

This pre-1907 postcard captures Greensboro's principal street with a streetcar on the tracks. The electric trolley system installed in 1902 had three routes: one on North Elm to the northeast; one on South Elm out Asheboro Street (now Martin Luther King Drive); and one on West Market to Lindley Park. Since "Wills Book Store" is printed in the lower left corner, this may have been a promotional card for the firm that was established in 1905.

Contents

Introduction — 6

1. A New Town (1808–1865) — 9

2. The Expanding City (1866–1900) — 29

3. A New Century (1901–1920) — 53

4. Greater Greensboro (1921–1945) — 83

5. The Modern City (1946–Present) — 117

Introduction

The growth of Greensboro's early neighborhoods, indeed the growth of the city itself, depended on the development of the railroad in the 19th century and the location of rail lines throughout the state. On January 29, 1856, local citizens gathered to witness one of Greensboro's most historic events—the arrival of the first train. John Motley Morehead, a former governor, had used his influence to make his hometown a station on the new North Carolina Railroad that ran from Goldsboro to Charlotte. Other rail lines were added in later years: the Piedmont in 1864, the Cape Fear and Yadkin Valley in 1888, and the Northwestern North Carolina in 1890. By 1891, the city was a hub for lines running in six directions, and 60 trains arrived or departed daily. This traffic led a newspaper editor to refer to Greensboro as "The Gate City," a nickname still in use.

When Greensboro was established in 1808, it covered only a quarter of a mile, and the new town was laid out in 14 blocks of lots that were sold at public auction. Some lots were purchased for commercial use or as investments, but others became residential sites. Early houses were clustered around the central courthouse square, near the churches built in the 1830s and adjacent to the 1846 campus of the Methodist college for women. After the Civil War, residential growth followed the railroads south of the business district where the lines and depots were located. Planned neighborhoods, such as Southside and Warnersville, became familiar names. Housing also was constructed around the campus of Bennett Seminary, located in east Greensboro in the 1870s.

In 1887, local voters passed a large bond issue which provided funds to extend Elm Street to the north and south. Originally only four blocks long, Elm had replaced Market as the principal street because of the rail lines, and its extension promoted additional residential growth. In 1891, the city limits were extended for a second time to cover 4 square miles.

Another stimulus for growth occurred in the 1890s when Moses and Ceasar Cone selected Greensboro as a site to manufacture textile goods. The brothers purchased land northeast of the limits and built Proximity (1896) and White Oak (1905) cotton mills. The Cones also encouraged other investors, including the Sternberger brothers, to move to Greensboro, and the Sternbergers built Revolution Cotton Mill in 1898. These factory owners built substantial houses along Summit Avenue, a new street described as "a magnificent boulevard soon to be graded and macadamized." Residences for factory supervisors and managers were nearby, and these surviving structures are part of the Charles B. Aycock Historic District. Self-sufficient villages for workers were developed around each of the mills, and East White Oak was created

as a separate village for blacks. All four of the villages were brought into the city in 1923 when the limits were extended for a third time to cover nearly 18 square miles.

By 1900, the western city limit reached the State Normal & Industrial College, now University of North Carolina Greensboro (UNCG), which opened in 1892. An area known as "West End" developed around the school, and it soon included more than 100 houses, five stores, and three churches. This area and an earlier one around Greensboro College now make up the College Hill Historic District.

Although people continued to build in established areas, new neighborhoods created around parks became popular in the 20th century. As early as 1889, Basil J. Fisher announced a development north of the city limits, and, in 1901, he further promoted the area by donating a tract of land as a city park. Located east and west of Elm Street, Fisher Park was almost a mile from the center city. Several houses constructed there were very grand while others were more modest, and the Fisher Park Historic District features survivors of both types. Religious buildings are an integral part of the neighborhood as well.

The construction of electric trolley lines spurred additional real estate development throughout the city, and the first trolleys ran on June 11, 1902. At the western end of the line was a residential area named for J. Van Lindley, who donated 26 acres to be a park. Lindley Park was adjacent to an earlier community named Pomona where owners and employees of Lindley Nurseries, the Pomona Terra Cotta Company, and Pomona Cotton Mill lived and worked. Pomona was considered a separate town until 1938.

The trolleys also served north Greensboro beyond Fisher Park, and, in 1911, the Southern Real Estate Company announced the opening of Irving Park, a new area which would have a nine-hole golf course and country club as its focal point. This carefully supervised project had streets designed to accommodate automobiles and houses that met minimum price guidelines.

Eastern Greensboro was not serviced by a trolley line, but neighborhoods for blacks centered around Bennett College and the Agricultural and Mechanical College, now North Carolina A&T State University, which opened in 1893. Nocho Park, established in 1928, was considered an exclusive black district with a park, hospital, and high school.

The 1920s brought many other changes. Due to the establishment of a city planning commission, restrictions were placed on neighborhood development; the city limits were extended to cover nearly 18 square miles; and a new ring of suburbs was constructed. Sedgefield, located southwest of the city, was designed around a golf course like Irving Park, but its master plan also included a horse show arena and resort hotel. West of Greensboro, A.M. Scales began a development which was incorporated as the town of Hamilton Lakes with Scales as mayor. It included natural lakes and a landscaped park; a golf course was to be added as the southern boundary. Beyond Hamilton Lakes was the town of Guilford College, which developed from a Quaker settlement dating back to the 1750s and a boarding school established in 1837. The City of Greensboro annexed Guilford College in 1962.

When the Hamilton Lakes company failed in 1929, the area came under the control of Blanche Sternberger Benjamin and her husband, Edward. They developed the Starmount Country Club and golf course and added a residential area with modest homes, naming this development Starmount Forest. There were numerous other residential projects in the 1920s and 1930s, including Lake Daniel, Westerwood, and Sunset Hills in the west, Latham Park in the north, and Kirkwood, Garden Homes, and Friendly Acres in the northwest. On a 1938 city map, 24 neighborhoods are identified within the 52-square-mile limits. Fifty years later there were more than 60 neighborhoods, and the number continued to increase as Greensboro grew to cover more than 100 square miles.

Selecting images to represent Greensboro's neighborhoods was a daunting project, made more difficult by the volume and variety of the Greensboro Historical Museum's holdings. The archives contains 15,000 photographic prints, more than 250,000 negatives, and 1,000 miscellaneous printed items, including postcards. Archivist Stephen Catlett reproduced the photographs included and assisted in many other ways.

A number of collections were used extensively. Negatives from the Art Shop, prints and negatives from Martin's Studio, and photographs donated by the Greensboro Public Library are featured throughout this book.

The Art Shop, owned by Charles A. Farrell (1893–1977) and his wife, Anne McKaughan, developed from a small frame shop to a facility with a studio, photographic supplies, and commercial photofinishing. Farrell, who came to Greensboro in 1923, became a noted regional photographer and took many photos for the *Greensboro Daily News*. His wife, who died in 1977, became a licensed professional photographer in 1942.

Carol Martin (1911–1993) came to Greensboro in 1938 as the "first full-time staff photographer for the *Greensboro Daily News* and the *Greensboro Record*." He began shooting pictures for the stories he reported for the *Roanoke Times* and was self-taught. Martin believed that photographers had to use their imaginations to shoot images that would make people stop and look. He left the newspaper business in 1946 and opened a photographic studio with his partner and fellow photographer, Malcolm Miller. In 1992, when he closed his studio, Martin donated more than 200,000 images to the museum.

In compiling this book, the primary objective was to share appropriate images from the museum archives, so only a few of the photographs were obtained from other sources. Another objective was to explain the development of some local neighborhoods through the houses, churches, and schools built for residents. Although this is not a comprehensive look at residential development throughout the city, it is a record of some of the places that helped shape Greensboro.

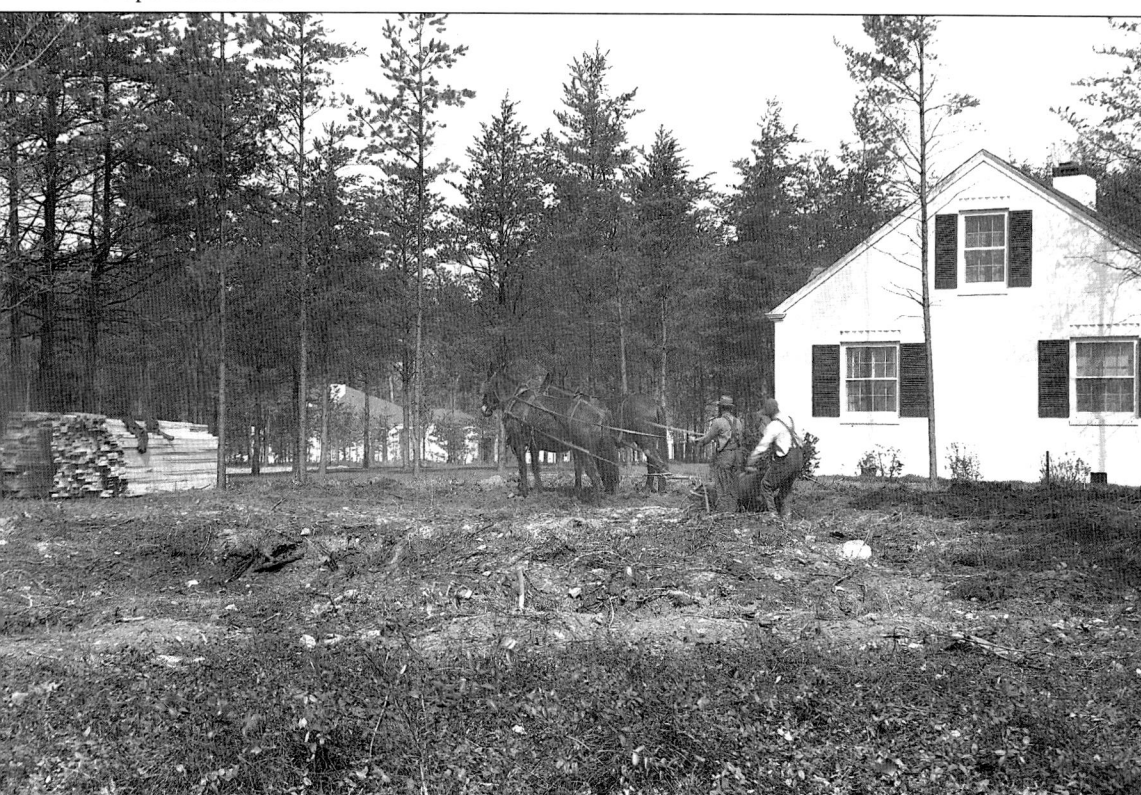

From Greensboro's earliest years to the present, the construction of houses has required clearing the land, obtaining materials, and selecting a building style as initial steps. In the late 1930s, the Starmount Forest neighborhood was created in west Greensboro, and the sales slogan for the new houses was "Designed for Living—Built to Endure."

One

A NEW TOWN
(1808–1865)

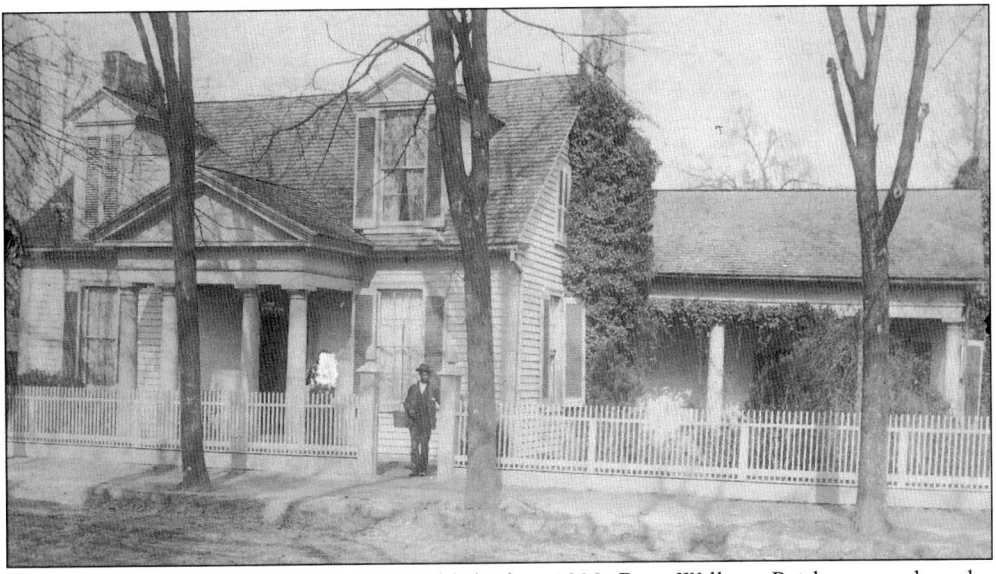

A dozen years after Greensboro was established in 1808, Rev. William Paisley moved to the small village and purchased a block of lots on West Market Street. He paid Thomas Caldwell $80 for the site that was just beyond the western town limit. Timbers salvaged from the 1774 courthouse and purchased from the county commissioners were used to construct a house. This mid-19th-century photograph reveals its large dormers and covered portico. Sarah, the youngest of six sisters, inherited the Paisley house in the 1850s and lived there with her husband, Robert Sloan, and their seven children. Frances Sloan, who married Dr. John E. Logan, then inherited the house and lived there well into the 20th century. Around 1930, the building was dismantled and moved to 409 Hillcrest Avenue in the new West Market Terrace neighborhood. Still standing, it is the oldest structure in Greensboro occupied as a residence. A U.S. Post Office that opened in 1933 was constructed on its former site.

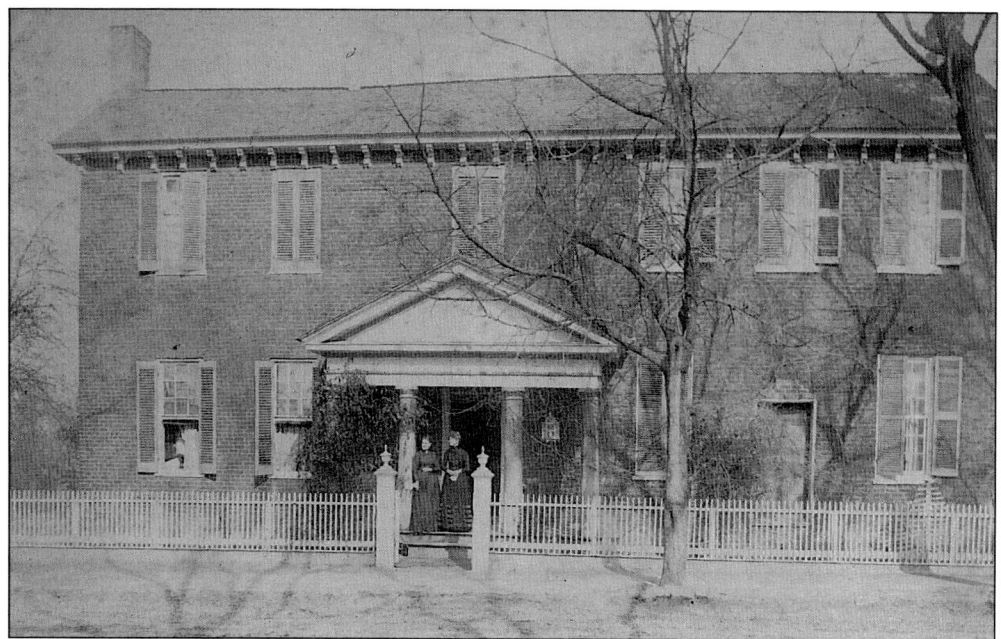

Two of Greensboro's earliest residents were Dr. David Caldwell Jr. and Thomas Caldwell, clerk of Guilford Superior Court. They were the twin sons of noted minister and educator David Caldwell, who had a plantation west of town. Around 1815, the brothers built substantial brick houses on adjoining lots on West Market Street, just inside the western town limit. David's house (top) faced the street and featured a small covered portico; the other house had large covered porches and faced west. Servants' quarters were built on the common property line. Demolished early in the 20th century, these houses were replaced by the 1918 county courthouse, which is still standing. Streetcar tracks are visible in the 1904 photograph of the Thomas Caldwell house (bottom).

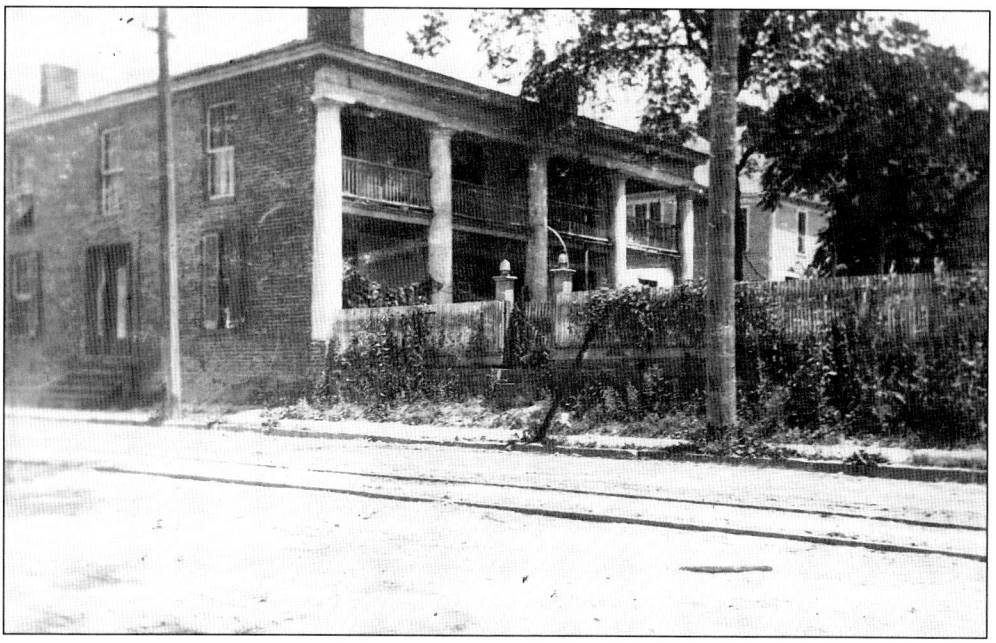

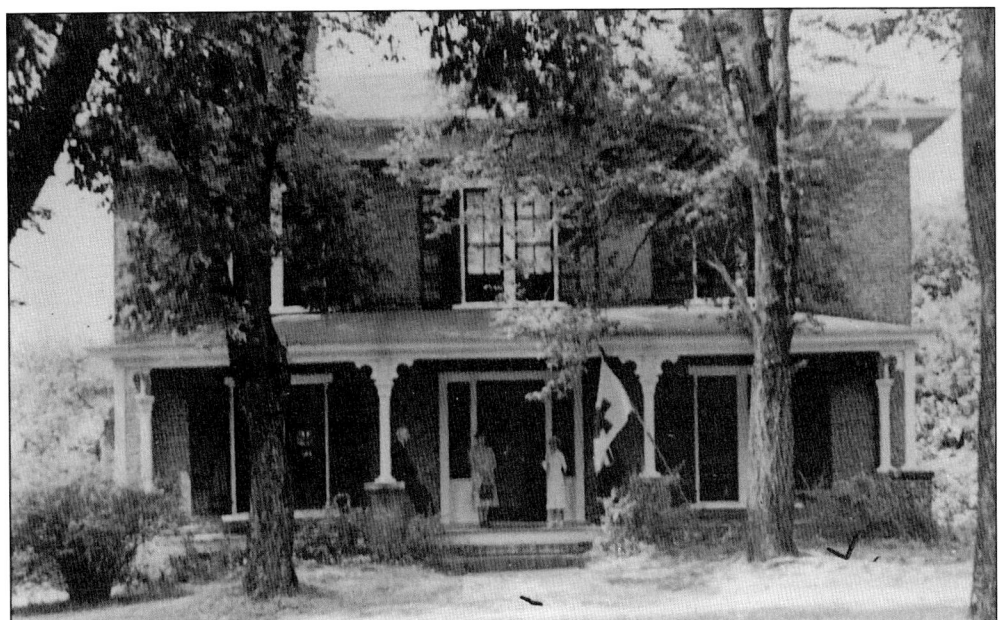

In 1853, bank President Addison Caldwell designed and constructed a two-story house at the intersection of Friendly Avenue and Eugene Street on a lot provided by his father, Thomas. Bricks used for the external and internal walls were molded and baked on the site. The extensive grounds surrounding the house were beautifully landscaped with gardens and an orchard. In 1874, Addison Caldwell moved to Tennessee, and his nephew, George Donnell, moved into the house. Descendants of the family owned the residence until 1939 when the City of Greensboro acquired it. In August 1939, the house became headquarters for the Greensboro chapter of the American Red Cross.

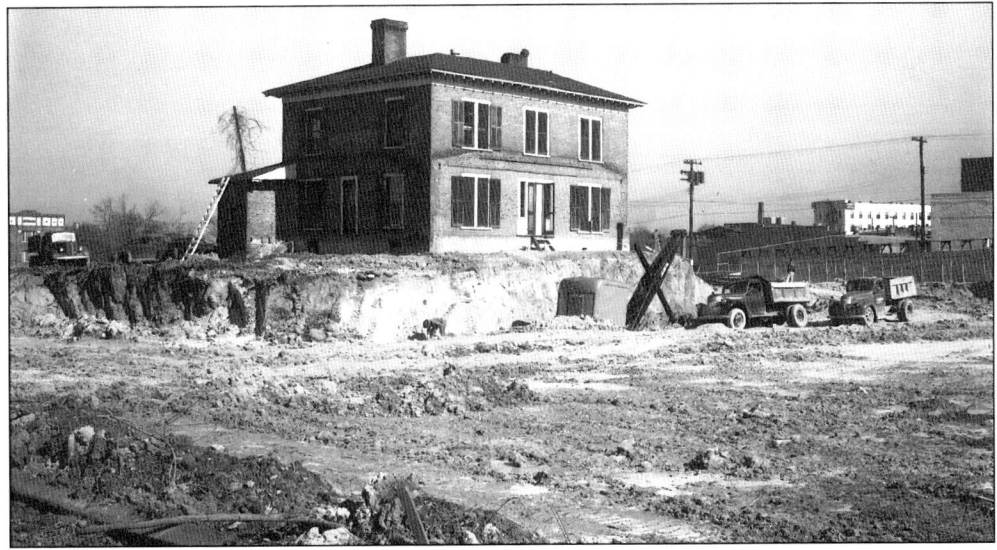

In 1947, the Caldwell property was sold and the house razed. A retail store for Sears was built on the site, and the Guilford County Mental Health Department has renovated that building for its use. (Copyright CM.)

Henry Humphreys, the wealthiest person in town according to the 1829 census, built this unique residence on the southwest corner of Elm and Market Streets around 1830. He operated a general store on the ground level, and his family occupied the other floors. By 1890, the building was a hotel with a drugstore at street level, and, from 1891 to 1897, the Keeley Institute, a sanitarium to treat alcoholics, was located there.

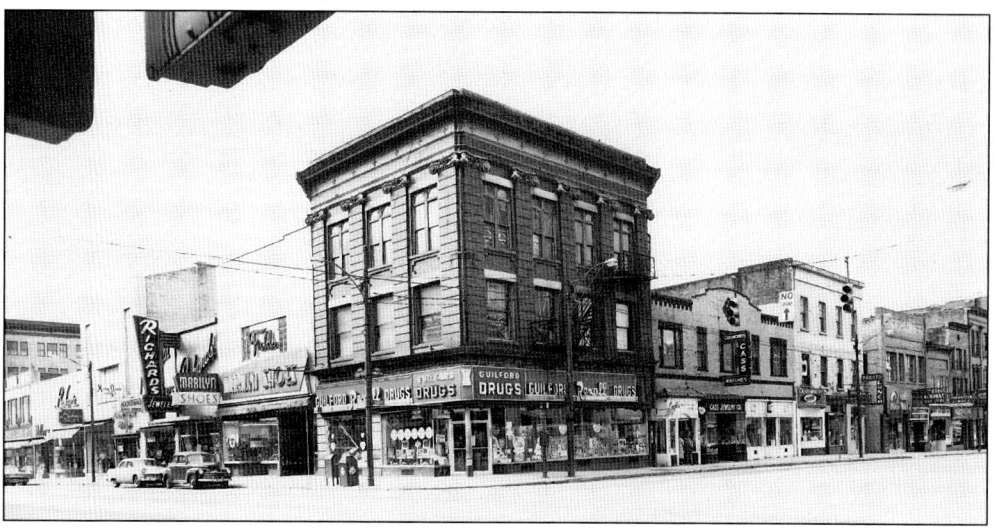

By 1959, "Humphreys Folly" had a new look with an altered roofline and a classical facade. Guilford Drug Store occupied the lower level that featured plate-glass windows and neon signs. The upper levels were subdivided into small offices. The building was razed in the 1970s, although some of the columns were left standing as part of a plaza. In 1983, First Citizens Bank constructed a new office building on the site.

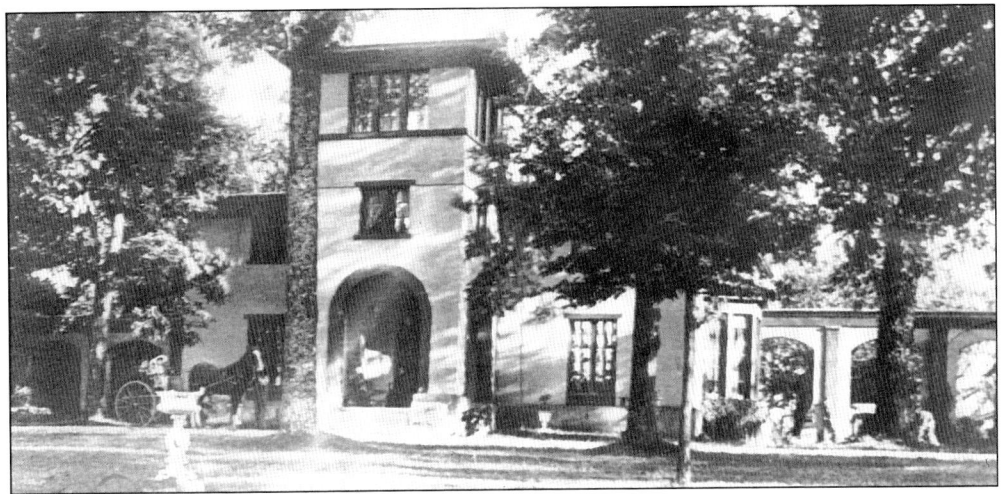

Blandwood, a house museum since 1976 and a National Historic Landmark since 1988, is the former home of Gov. John Motley Morehead. From Washington Street the residence resembles an Italian villa with arcades leading to dependencies that originally served as an office and kitchen. New York architect A.J. Davis designed this portion of the house, completed in 1845. The rear of the house is composed of an early farmhouse owned by Charles Bland and an addition made by a later owner, Henry Humphreys. Humphreys sold the house to Morehead, his son-in-law, in 1827, and it remained in the Morehead family until 1897, when it was converted into the Keeley Institute. After the Keeley closed in 1961, the building was purchased by the Greensboro Preservation Society organized in 1968. In the bottom photograph, patients are enjoying a game of croquet (Copyright CM).

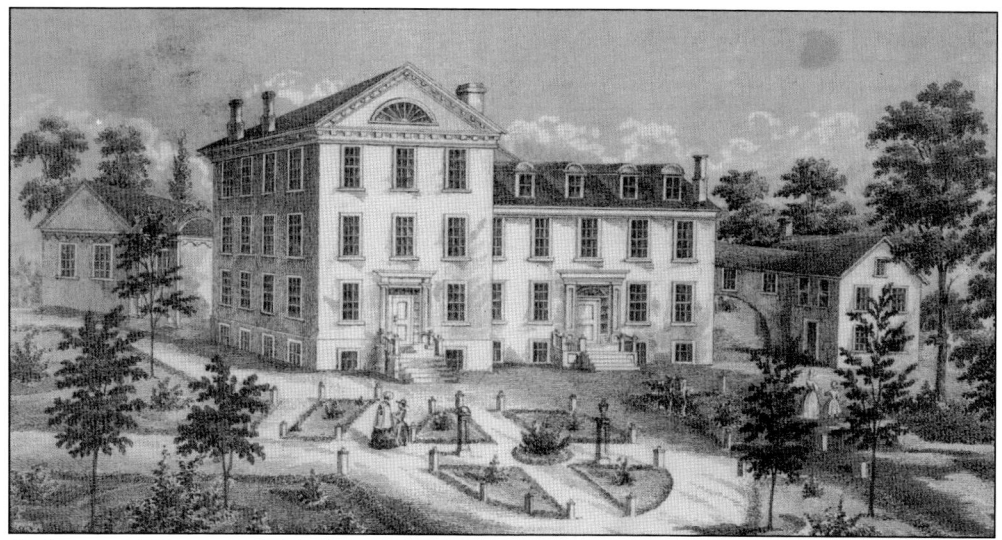

Architect A.J. Davis probably designed this handsome building for Edgeworth Female Seminary. Governor Morehead, the father of five daughters, established the school to educate Southern women in 1840. Edgeworth, located northwest of Blandwood, closed during the Civil War. Reopened in 1868, it closed permanently in 1871, and the building was destroyed by fire.

The female school established by Greensboro Methodists in 1833 was more successful. In 1838, it was chartered by the State as Greensboro Female Seminary, and, in 1841, it became a college. The school was moved to its West Market Street campus in 1846. This postcard image features Main Building, and the Walker-Scarborough House, one of the earliest in the College Hill neighborhood, is visible at the end of the dirt lane.

The Troy-Bumpass House at 114 S. Mendenhall Street was listed on the National Register in 1987 and opened as a bed-and-breakfast in 1992. Sidney Bumpass, a Methodist minister, built the house near Greensboro College in 1847, and his descendants lived there until 1975. Frances Bumpass used her home to raise three children, as well as a school, a boardinghouse, and a site to print the *Weekly Message*, a religious newspaper. The area around this well-known house became known as "Piety Hill" and is now part of the College Hill Historic District, created in 1980. In 1911, the residence was expanded slightly; the columns were shifted forward and a bay window and shed dormer were added.

The women of West Market Street Methodist Church held a farewell party for Nina Troy in 1912 when she left Greensboro to serve as a missionary in China.

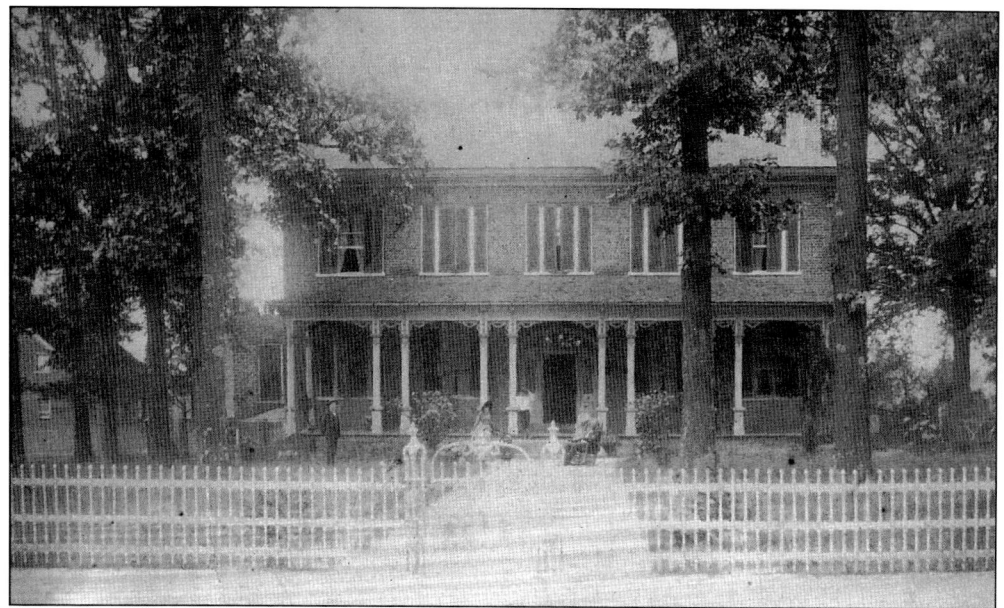

According to family tradition, J. Harper, Jesse, and Robert Lindsay built this house and agreed that the first brother to marry would keep it for his family. It stood at the northern end of Elm Street near the Bellemeade-Summit intersection. Harper Lindsay married first and stayed in the house but later replaced it with a larger one on the same site. Lindsay Street is named for the Lindsay family.

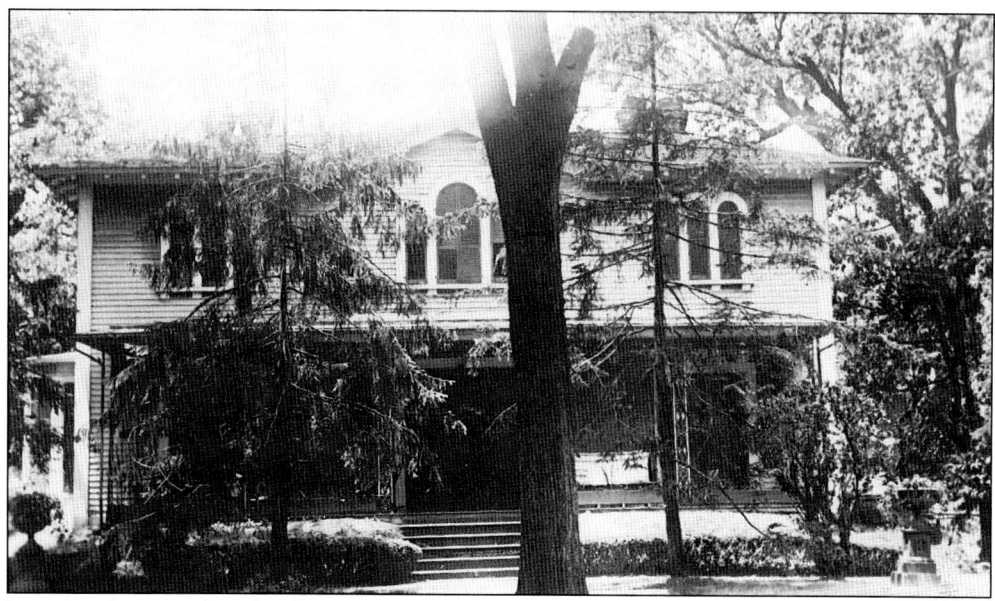

Jesse Lindsay purchased a lot on the southwest corner of the Elm-Bellemeade intersection and built this ten-room frame house before 1859. It featured a central gable and bay windows. Around 1916, the house was moved on rollers a block to the south, so that the O. Henry Hotel could be constructed on its former site. Jesse Lindsay donated the land for the original Presbyterian Church in Greensboro, and he is buried in the cemetery now behind the Greensboro Historical Museum.

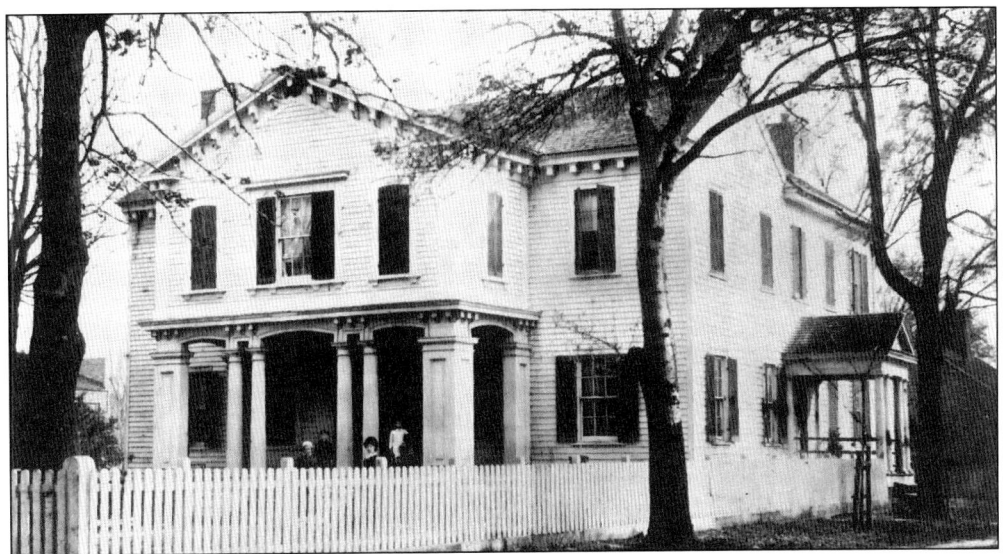

Departing from family tradition Robert Lindsay built his home in southwest Greensboro facing Sycamore Street at the Greene Street intersection. Early in the 20th century, this large Italianate-style structure was moved to the south on Greene Street to make room for a new Elk's Lodge. The house was razed around 1940.

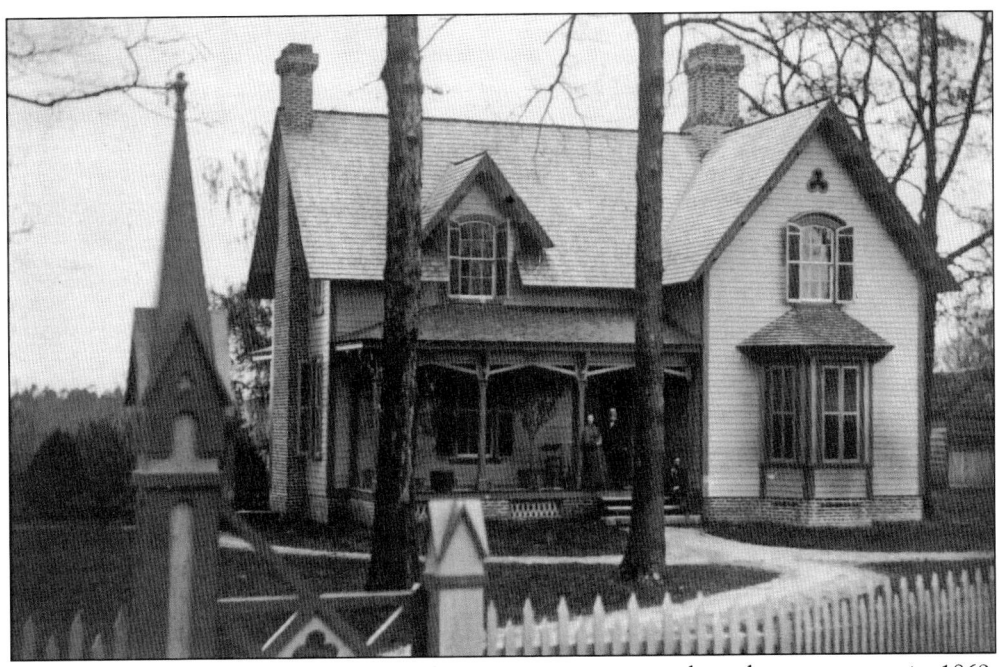

Lyndon Swaim, a newspaper editor and town commissioner, adopted a new career in 1869. For the next 20 years he was Greensboro's leading architect. Harper Lindsay commissioned Swaim to design this Gothic-Revival cottage which stood at 113 Church Street (now Summit Avenue). John A. Gilmer acquired Lindsay's former Elm Street residence.

In 1832, John Adams Gilmer married William Paisley's daughter Julia, and his father-in-law built the young couple a house on the eastern half of his West Market Street lot. Gilmer became a successful lawyer and was elected to the U.S. House of Representatives in 1857. This house was removed in the 1890s when the property was purchased to build West Market Street Methodist Church.

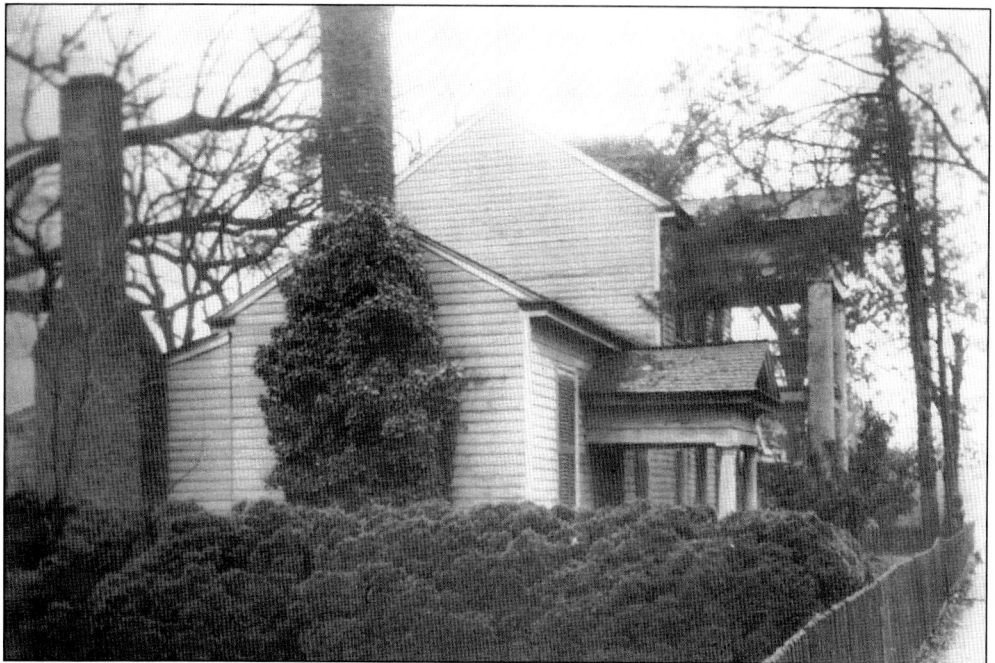

W.S. Hill was the third owner of this Colonial-style house at 317 West Market Street. According to local tradition, it was built in the 1830s and Confederate soldiers were entertained there. The six-room house, with its dominant porches, was the first one in Greensboro to have a doorbell. It was razed and replaced by the Greensboro Motor Car Company.

The Ridenhour House at 417 West Market Street was built in the 1830s and purchased by William Bevill in 1877. His daughter, Dora Ridenhour, continued to live in the house for many years. This image, taken in 1958 by a student at Greensboro Senior High (now Grimsley), was entered in a photography contest.

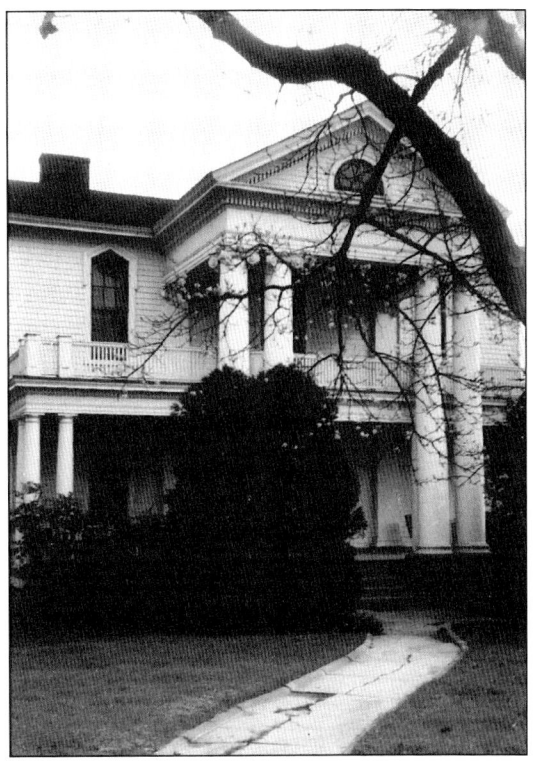

Julius and Emma Morehead Gray lived in this house before they purchased Blandwood in 1878. Currently the Arbor House Antique Shop at 605 West Market Street, it is one of the few surviving houses in the city built before 1880. The fan light in the east gable is thought to be one saved from the Edgeworth building that burned in the 1870s.

Farther out West Market Street, Peter Adams built this Colonial-style home in 1854. Opposite Greensboro College, the estate included a barn, toolhouse, garden, and orchard. R.L. Justice acquired the house and remodeled it in the 1920s. It was razed after World War II.

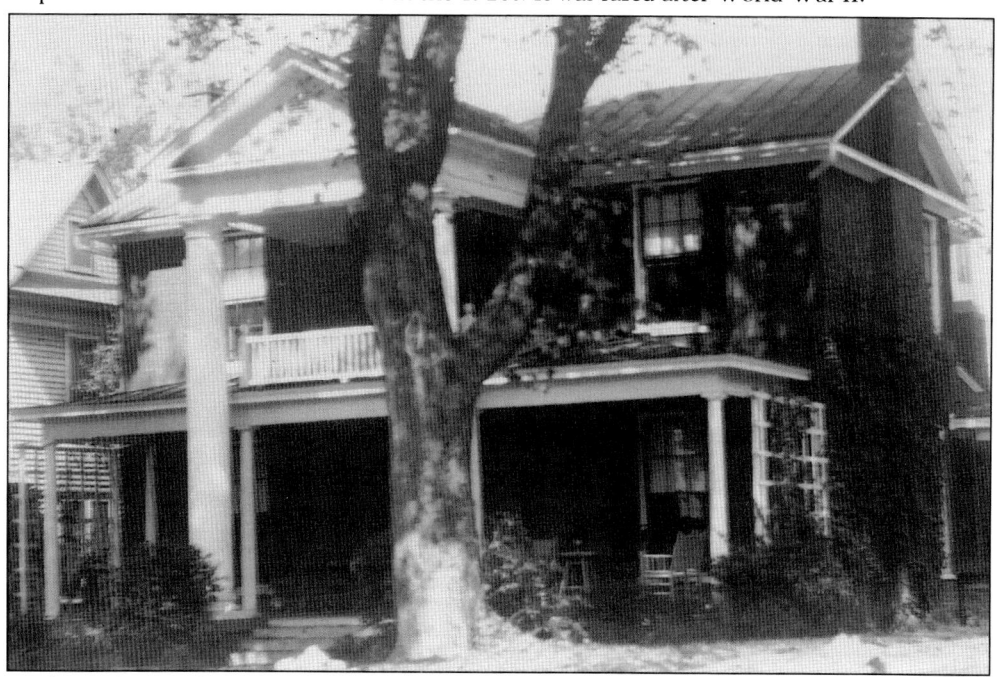

Michael Sherwood, publisher of the *Greensborough Patriot*, built the Sherwood House shortly after 1849. He located it on a 5-acre tract of land purchased from Greensboro Female College. Sherwood descendants still owned the house in 1976, when a group of lawyers purchased it to restore and use for offices. The house, still standing at 426 West Friendly Avenue, was listed on the National Register in 1978.

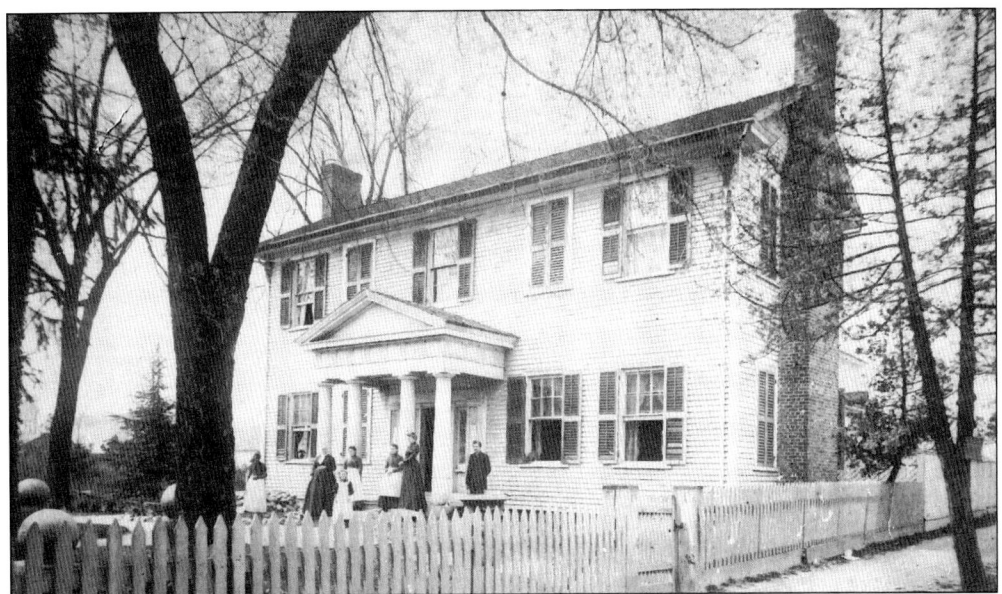

In 1856, Cyrus Pegg Mendenhall purchased 6 acres of land on South Elm Street and built this handsome house at the Washington Street intersection. The landscaped grounds around "The Elms" included Greensboro's first greenhouse. According to local tradition, the house was moved to 220 Fisher Avenue in the 20th century when South Elm became less desirable as a residential address. A number of exterior alterations have been made. These 19th-century photographs show members of the family in the front yard and the parlor and music room. Mendenhall, a member of a prominent Quaker family, joined the Methodists when he married non-Quaker Nancy Staples. He was active in business affairs and served three terms as mayor of the city.

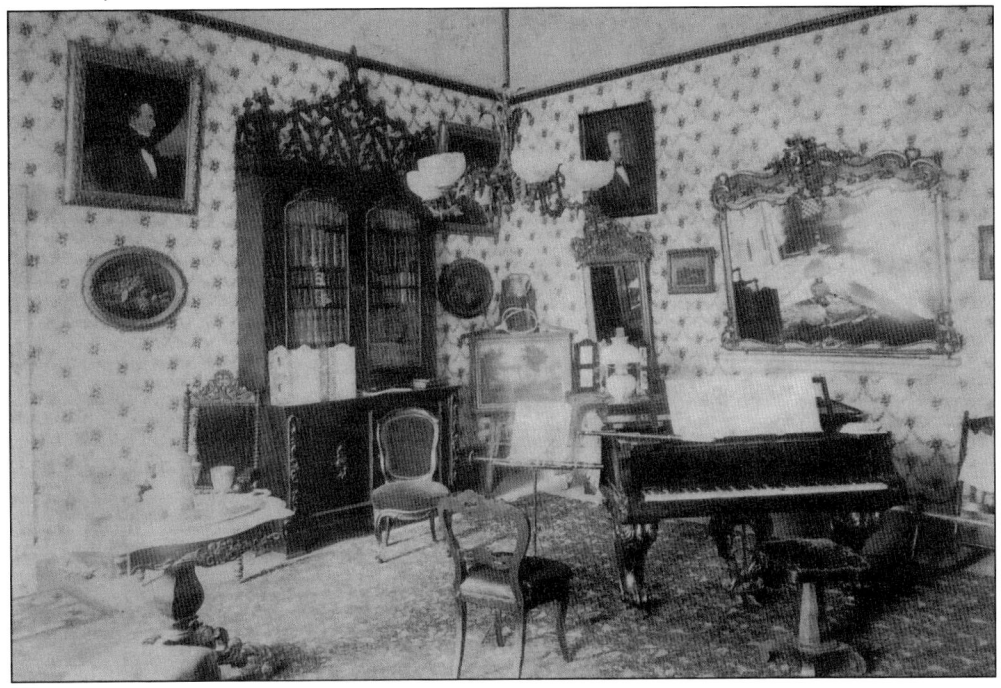

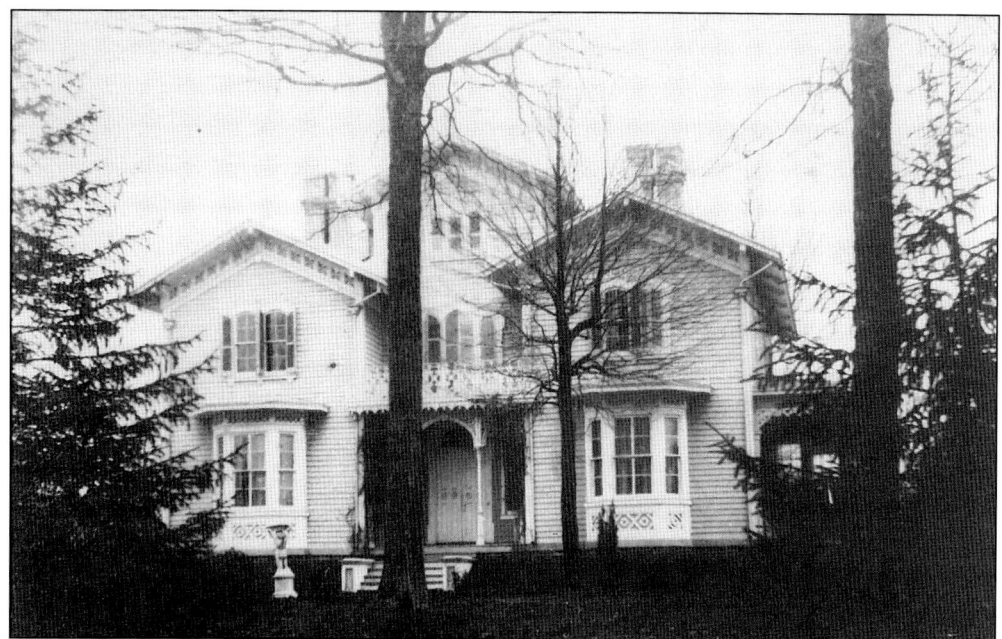

Dunleath, one of Greensboro's most outstanding houses, stood northeast of the business district from 1856 until 1969 when it was razed. A Philadelphia architect, commissioned by Judge Robert P. Dick, designed the residence to resemble a Swiss chalet, a style well suited to its location in a grove of oak trees surrounded by 200 acres. Expensive options included iron pillars and trim, porcelain doorknobs, and sterling silver hardware on the front door. Union General Jacob Cox had his headquarters in the Dick home at the end of the Civil War. The interior image of Dunleath's parlor was taken while William Trotter, a member of city council from 1959 to 1971 and mayor from 1965 to 1967, owned the home.

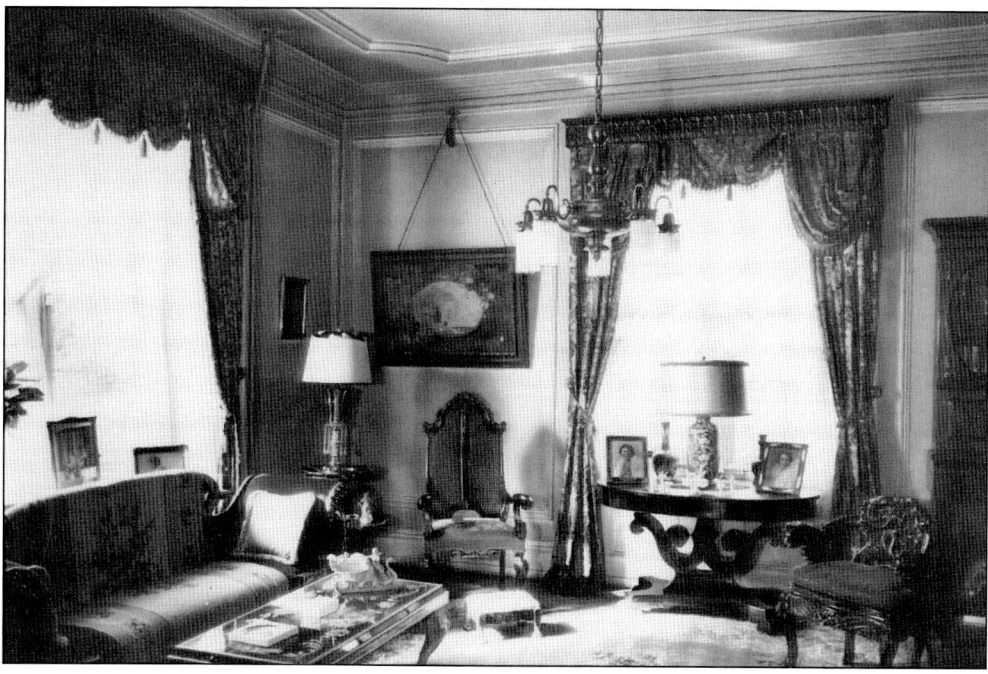

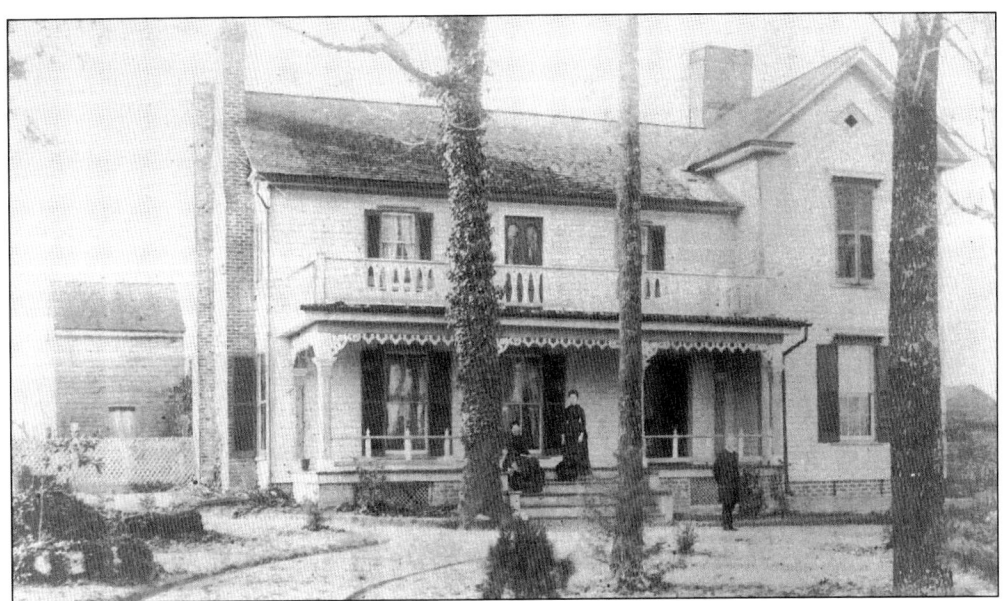

In 1859, the new Presbyterian minister, Jacob Henry Smith, arrived in Greensboro. His family moved into this manse on Church Street beyond the Lindsay Street intersection. Smith purchased the house and approximately 16 acres from Robert Dick for $2,639. There is a description of the residence in Mrs. Smith's journal: "The house was neither new nor large, but in good repair, having two porches, four small rooms on each floor, a good attic and large cellar, used by former occupants as a dining room . . . it was cozy and comfortable for our small family, with a spacious fireplace and two south windows in the living room and a charming outlook and beautifully shaded lawn." In 1906, Mrs. Smith, a widow since 1897, moved in with a daughter and the old manse was razed. She noted in her journal that she survived only because she was "essentially progressive."

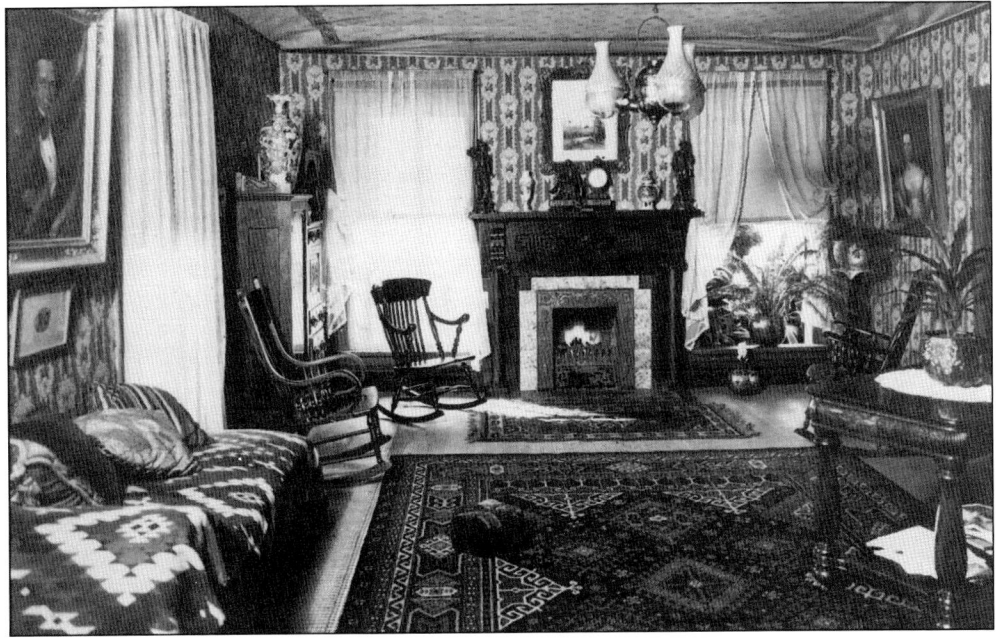

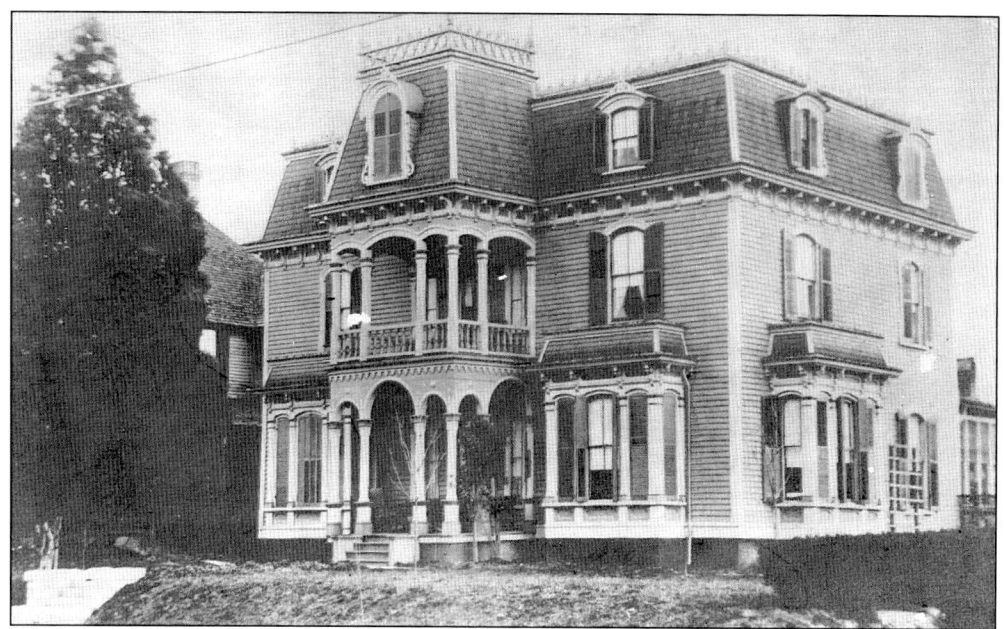

Charles Green Yates, mayor from 1857 to 1860, built his house, Greenwood, in the Second Empire style sometime before 1859. It stood across from the Smith's manse on Church Street. Later, the house was moved to 412 North Elm Street and occupied by the family of A. Wayland Cooke, an attorney and local postmaster from 1916 to 1920. The house was razed in the 1950s.

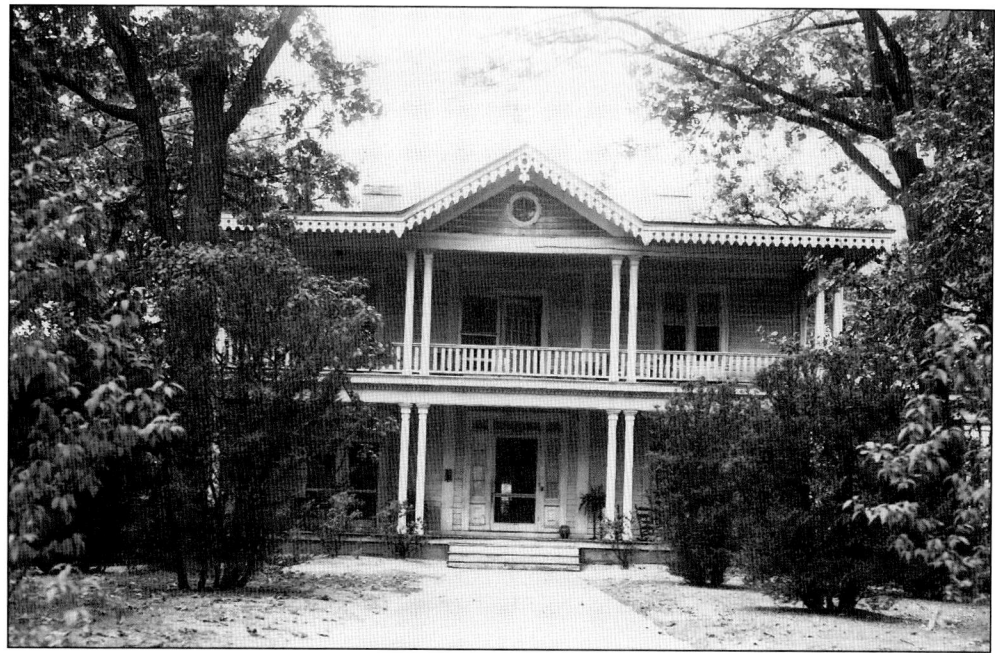

Dr. David Weir and his bride, Susan Humphreys, also purchased land from Greensboro Female College, and their 6-acre tract reached from Edgeworth Street to Spring Street. A.J. Davis may have designed the Weir House, built around 1846. The Greensboro Woman's Club purchased it as a clubhouse in 1921 and enlarged it in 1961. The house was listed on the National Register in 1984. This photograph was taken in 1946. (Copyright CM.)

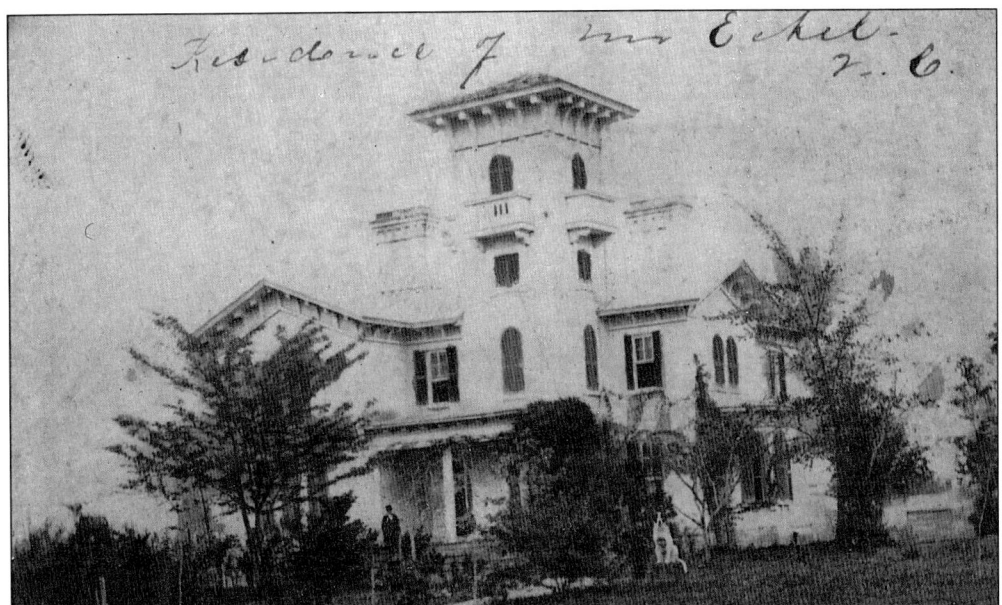

Mayor A.P. Eckel built this eclectic home on the southeast corner of Washington and Davie Streets around 1850. Rose Villa was surrounded by beautiful grounds which earned Greensboro an early nickname as the "City of Flowers." According to legend, Confederate treasury officials buried silver there in 1865, but when U.S. Gen. Judson Kilpatrick occupied the house, he searched the grounds unsuccessfully. Rose Villa burned around 1885.

Ralph Gorrell, grandson of the man who provided the site for Greensboro, chose the southeast for his home also. Built of chocolate-colored handmade brick, the Italianate residence stood on a 7-acre site. During the Civil War, the grounds were used by Confederate troops as a resting-place and probably for Gen. Joseph E. Johnston's speech to his troops following his surrender to Gen. W.T. Sherman.

25

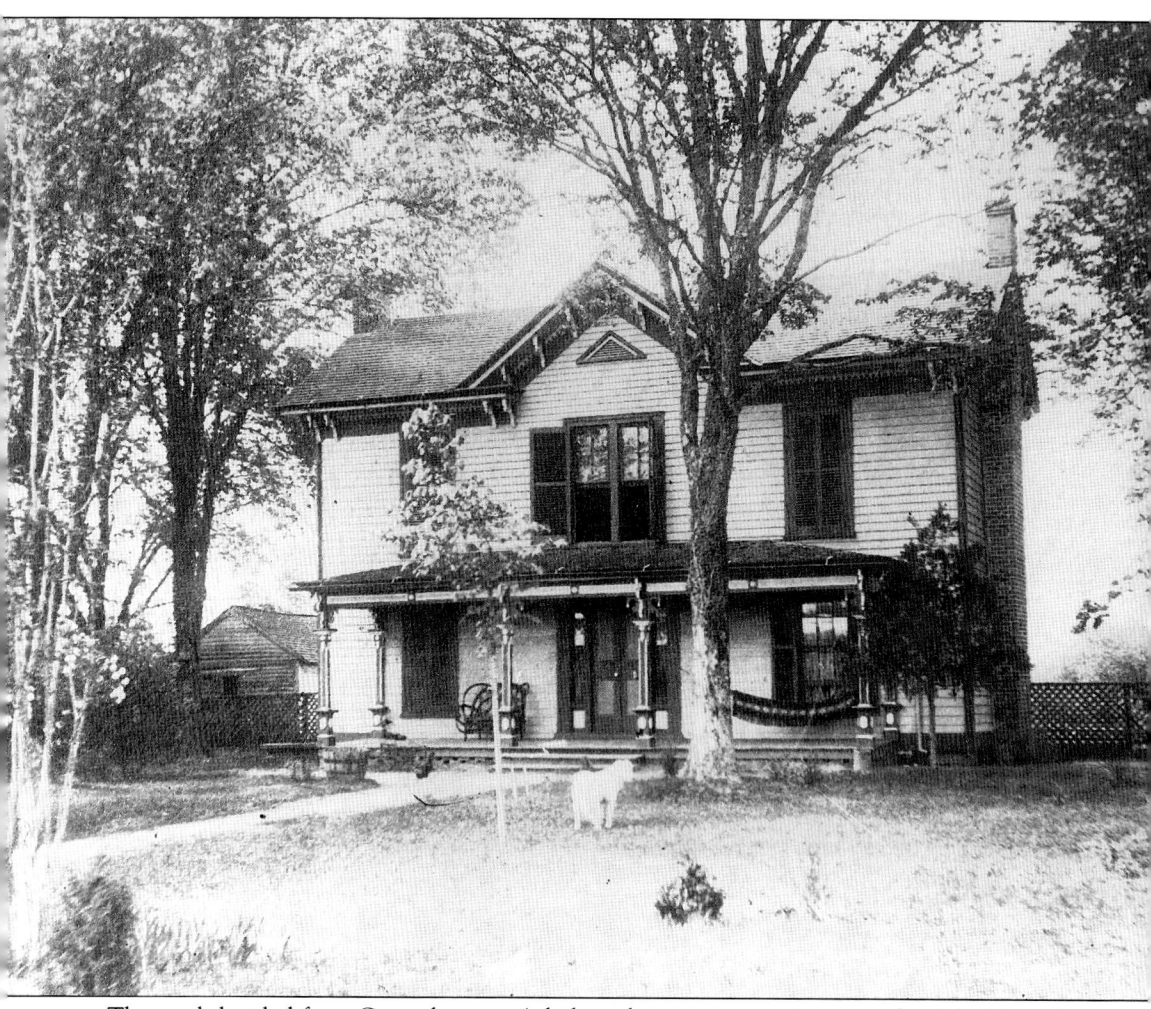

The road that led from Greensboro to Asheboro became a prominent residential address late in the 19th century, but houses and farms bordered the road a century earlier. In 1783, the State of North Carolina granted Daniel Gillespie a 300-acre tract on South Buffalo Creek. The Revolutionary War veteran paid 150 shillings for the property and built a log house that was later covered with weatherboarding. It was designed with two large rooms downstairs divided by a large central hall and an identical second floor. Elm and holly trees, as well as flowering shrubs, surrounded the house eventually identified as 1720 Asheboro Street. Although the Gillespie home was razed in 1960, both Gillespie School and Gillespie Golf Course kept the family name alive. Colonel Gillespie died in 1829 and is buried in the cemetery of Buffalo Presbyterian Church.

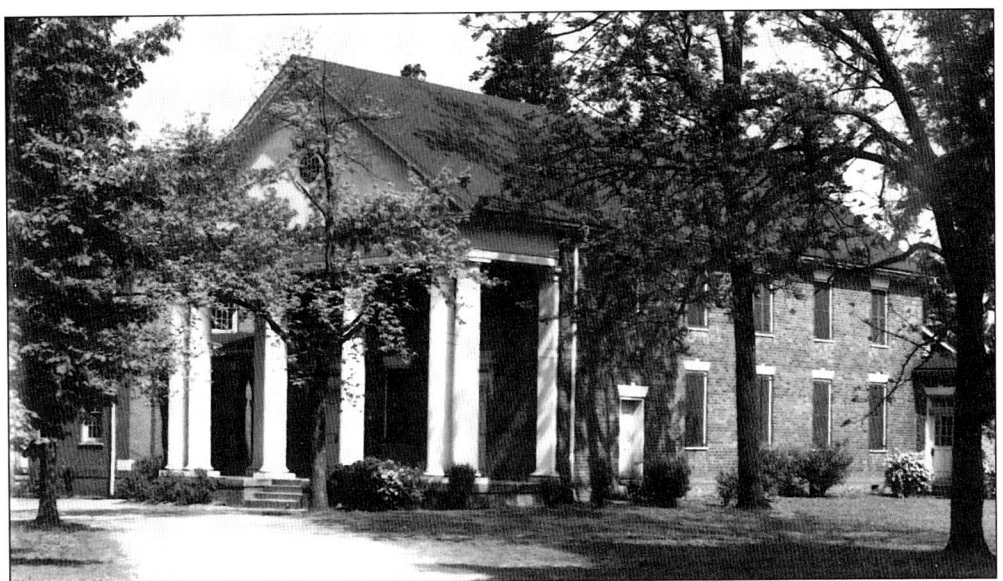

Scotch-Irish immigrants who arrived in piedmont North Carolina around 1753 organized Buffalo Presbyterian Church in 1756. The congregation called David Caldwell to be its minister in 1765. Two buildings were used before a brick sanctuary on Sixteenth Street at Yanceyville was completed in 1827. This photograph includes a Sunday school wing and portico added in 1920. A historic cemetery adjoins the church.

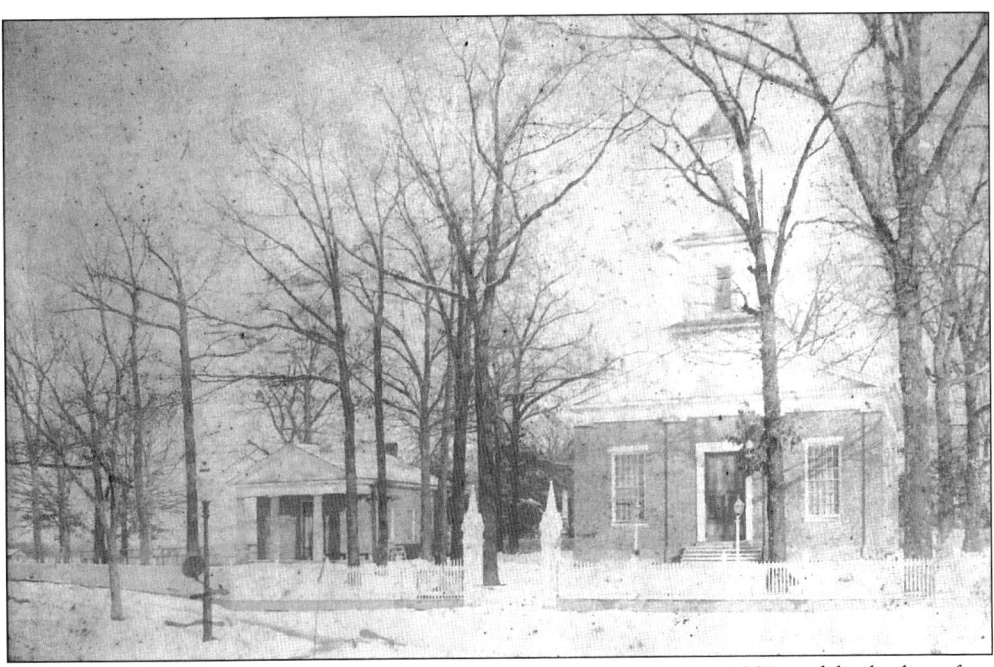

Presbyterians living in Greensboro organized as a congregation in 1824 and built their first church on land donated by Jesse Lindsay. This photograph is of the second sanctuary that was built in 1846 and used until a third church was constructed in 1892. The small building is a lecture room that was replaced in 1903. This church, in use during the Civil War, was a temporary hospital for the Confederate soldiers wounded at Bentonville.

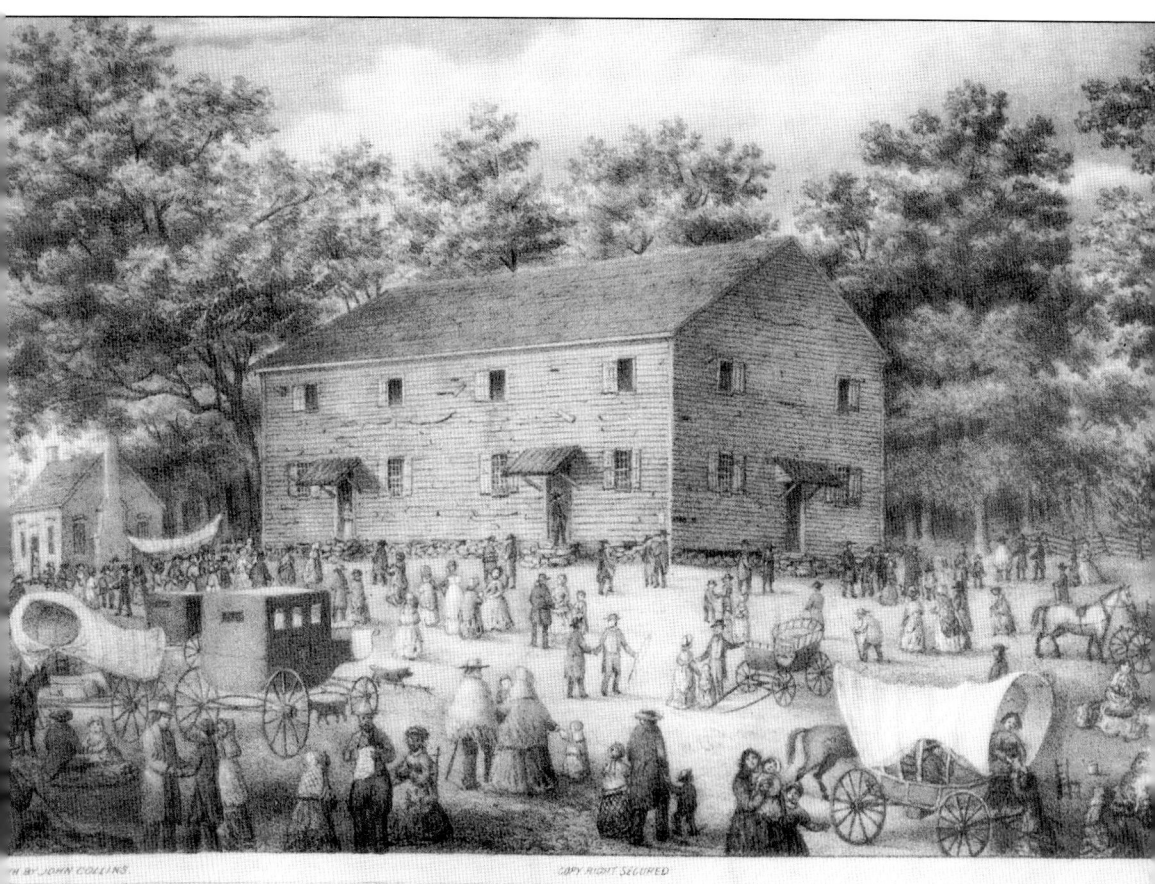

FRIENDS' MEETING HOUSE
AT NEW GARDEN—NORTH CAROLINA, 1869
ERECTED IN 1791.

The Quakers, or Friends, people bound together by their religious beliefs, arrived in this area in the 1740s. About 40 families created a community in northwest Guilford that they named New Garden, and, in 1754, they established the New Garden Monthly Meeting to conduct business. Members of the meeting included John and Anna Payne, the parents of future First Lady Dolley Payne Madison. The meetinghouse pictured here was built in 1791, and artist John Collins of New Jersey made this watercolor sketch. He visited New Garden in 1869 to attend the North Carolina Yearly Meeting of Friends. Collins included the people, their campfires, and wagons. In 1837, North Carolina Friends established New Garden Boarding School, the state's first coeducational institution. It became Guilford College in 1888.

Two

THE EXPANDING CITY
(1866–1900)

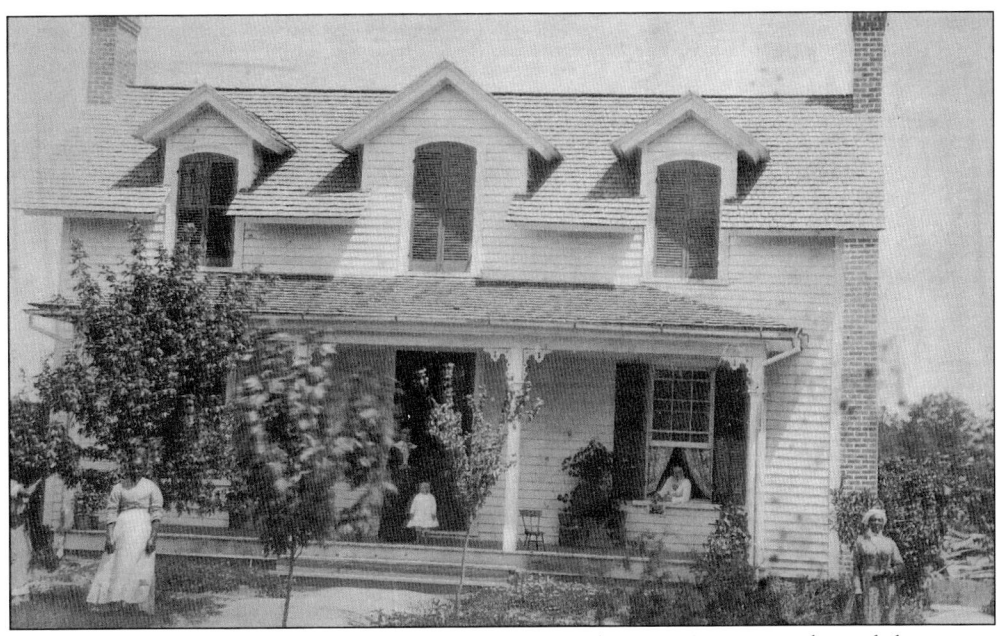

In 1882, a series of photographs titled "Views of Greensboro, N.C." was made, and there were nearly 200 images in the collection. This photograph of the William M. Houston House at 114 Clay Street was Negative No. 162. The names of family members and servants have been added to the museum's copy, and the small chair shown on the porch is in the museum's collection. The child Shelton served as a Greensboro librarian from 1903 until 1917 and was also an avid photographer. Mr. Houston operated a wholesale and retail grocery store at 215 South Elm Street, and his family continued the business after his death. Clay Street, now a portion of Battleground Avenue, ran northwest and Church Street northeast from the terminus of Elm Street two blocks north of Market.

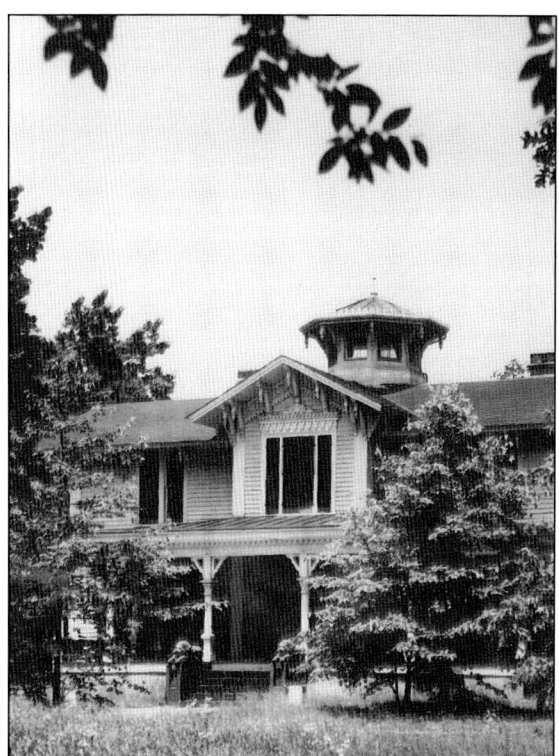

Belle Meade, an Italianate-style residence with nine rooms and numerous outbuildings, was owned by one family for nearly a century. Henry Humphreys and Eliza Hill Tate built the house in 1867 and furnished it with family items and new purchases. The owners chose a French name meaning "beautiful meadow" for their home. Originally part of a 15-acre country estate, the house eventually faced Bellemeade Avenue near the Edgeworth Street intersection. The Tates had four children, and their daughter, May Walsh, inherited the house, living there until her death in 1952. When her daughter, Nelson Hughes, inherited the house, she sold it for a commercial use. The house was razed in 1954, and the museum acquired many of the furnishings and the cast iron lions that guarded the entrance. The Belle Meade parlor, photographed in 1951, has been reproduced at the museum.

Around 1870, Thomas Settle, an attorney, judge, and justice of the North Carolina Supreme Court, built this house in the 400 block of Asheboro Street. In 1872, a local newspaper said Asheboro was "fast becoming one of the most beautiful streets of the city and a very desirable place to live. We learn there is a great demand for lots for building purposes in this street." Dr. William Paisley Beall, who married a Settle, bought the house in 1896.

Lyndon Swaim, Greensboro's leading architect in the 1870s and 1880s, designed his own home that stood on Lyndon Street in east Greensboro. The street, named in his honor, ran between Washington and Market, east of Forbis (now Church). The gabled house stood in a tree-shaded yard, and the porch was a favorite family gathering spot. Mr. Swaim, who died in 1893, is shown in this photograph taken a few years before his death.

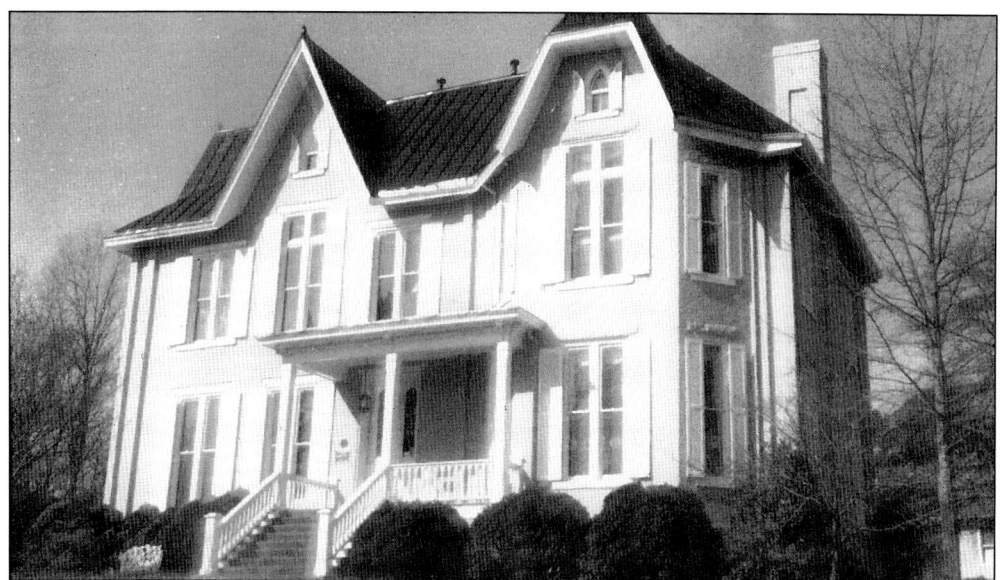

Carlson Farms Antiques (507 N. Church Street) was constructed as a residence in 1875. According to local tradition, Lyndon Swaim was the architect and Martin Dixon the original owner. After Dixon's death in 1886, Alex Leftwich acquired the house, and his son-in-law, Mayor Thomas J. Murphy, was the owner from 1903 to 1940. This Gothic-Revival structure was restored in 1982 and listed on the National Register in 1983. (Photograph from *Greensboro: An Architectural Record* by Marvin A. Brown [1995].)

Built around 1888, this Gothic-Revival cottage served as office and residence for the gatekeeper responsible for the new city cemetery, Green Hill. It resembles a duplex with a pair of doors leading to public and private spaces. Located at 700 Battleground Avenue, the house was separated from the cemetery by the extension of Fisher Avenue. Purchased and restored in 1978, it was listed on the National Register in 1979. (Photograph from *Greensboro: An Architectural Record* by Marvin A. Brown [1995].)

The William Fields House (447 Arlington Street) is another Gothic-Revival structure surviving in Greensboro. Fields built his home in the new Shieldstown neighborhood in the 1870s, and Lyndon Swain was probably the architect. This photograph from Mrs. P.A. Hayes's scrapbook includes the house and a new car. The Fields House was restored in 1979 and listed on the National Register in 1985.

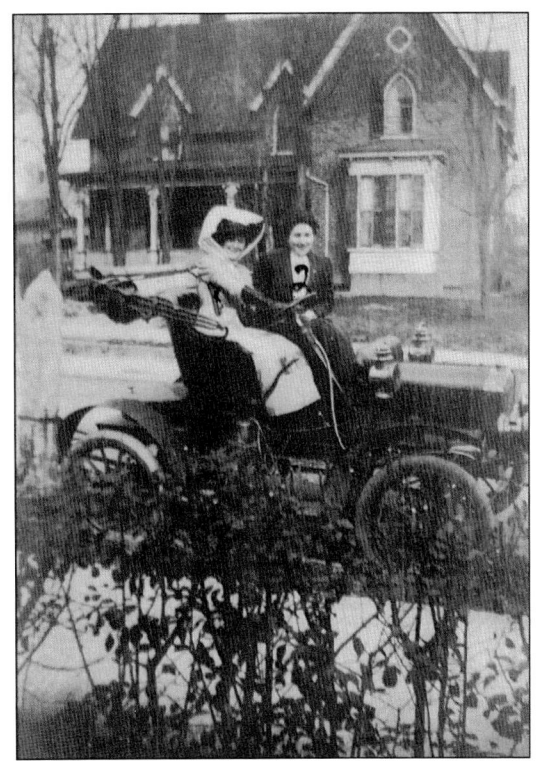

This photograph, taken in the yard at the John McNairy House (507 Arlington Street) around 1906, features Francis McNairy Glascock Demaree wearing some new "Blue Bell" overalls made by Charles C. Hudson. Hudson's firm began on South Elm, moved to Arlington, and moved back to Elm and Lee by 1910.

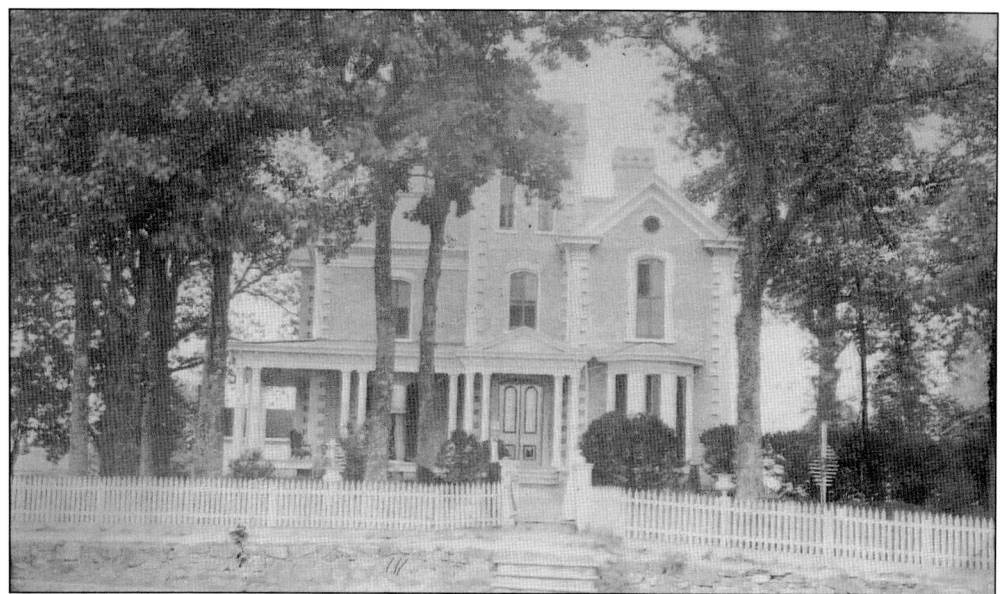

Levi Scott, a prominent attorney whose office is reproduced at the Greensboro Historical Museum, commissioned Lyndon Swain to design a Shieldstown house for him. It stood south of the railroad tracks at 124 Fayetteville Street (later Asheboro Street). This photograph, part of the 1882 series, reveals another example of the Gothic-Revival style, so popular in Greensboro at the time. The Scott House was demolished in 1953.

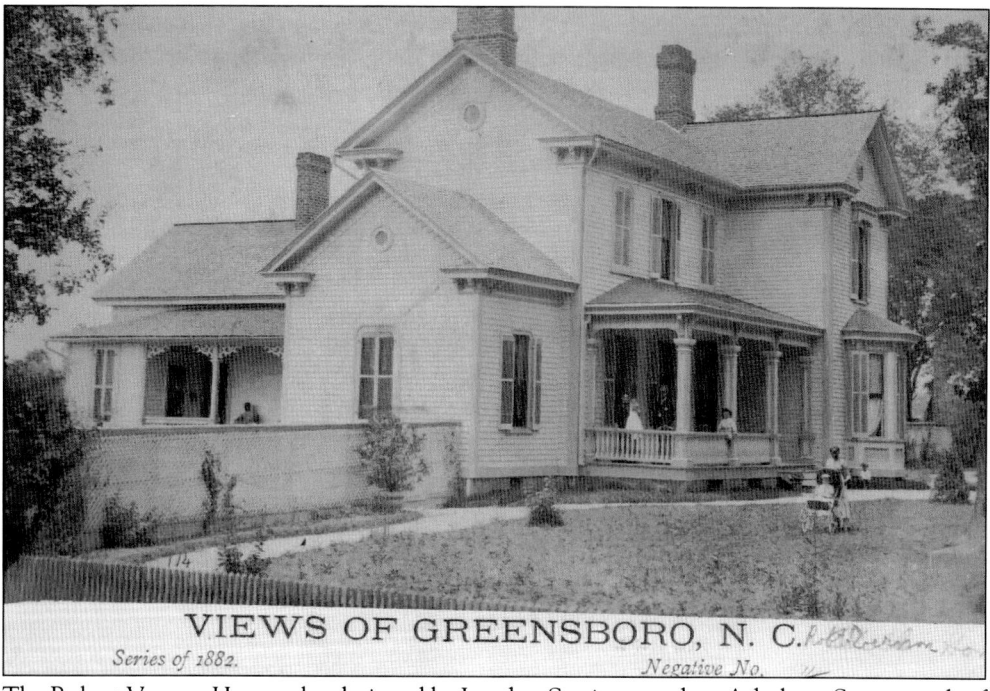

The Robert Vernon House, also designed by Lyndon Swaim, stood on Asheboro Street north of the Lee Street intersection. Vernon, an agent for the Richmond & Danville Railroad, selected a more traditional style for his home. Family members and servants are included in this image.

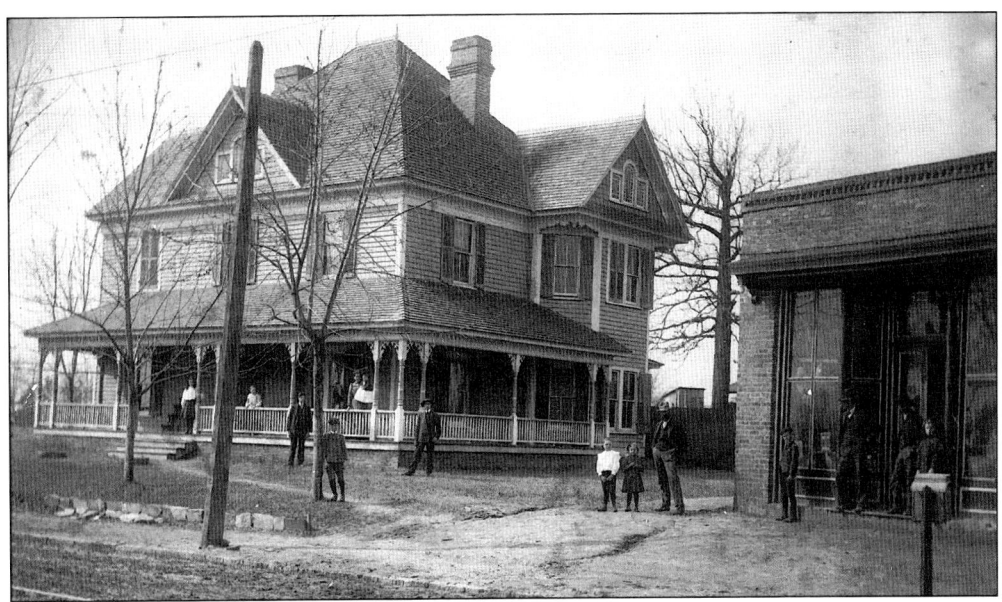

John S. Barnes built his house at 704 Asheboro Street in 1899. It stood beside the family-operated grocery store. Family members and neighbors are included in this photograph taken around 1905. Richard Holmes Milton purchased the house and lived there for 75 years.

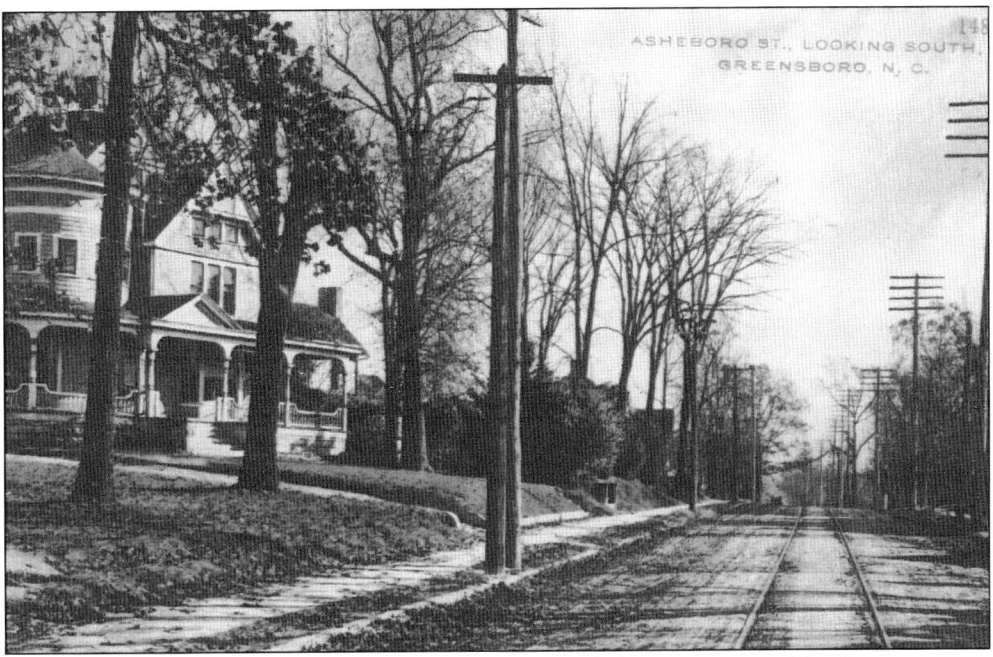

As early as 1872, a local newspaper proclaimed that Asheboro Street was "fast becoming one of the most beautiful streets of the city and a very desirable place to live." Many prominent men built their homes along this thoroughfare that also became a major streetcar route. This postcard, featuring the Charles Watson house, depicts Greensboro's premier neighborhood at the turn of the century.

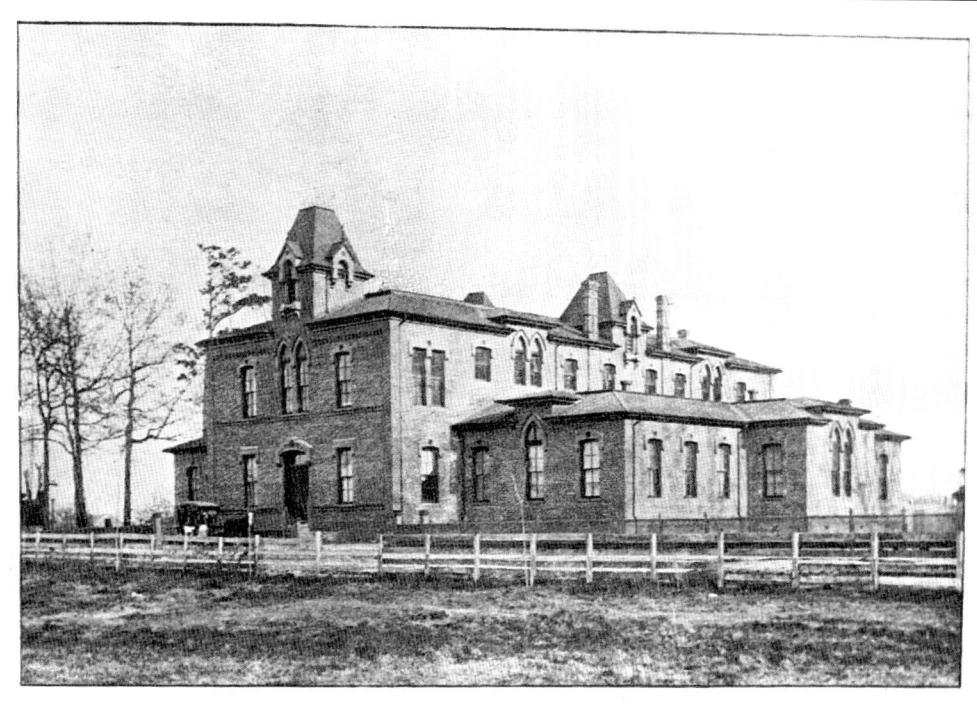

In 1886, the citizens of Greensboro raised funds to build a graded school for white children because an earthquake damaged the 1875 facility. Completed in 1887, the school was behind the Presbyterian church facing Lindsay Street and was named for the street, a practice used in Greensboro until 1922. It was "equipped with the most modern school furniture" available and included a chapel. This picture was made in 1890, after two detached rooms were added for primary students. The Lindsay Street facility was in use until 1925. This eighth-grade photograph (bottom) was taken in 1896.

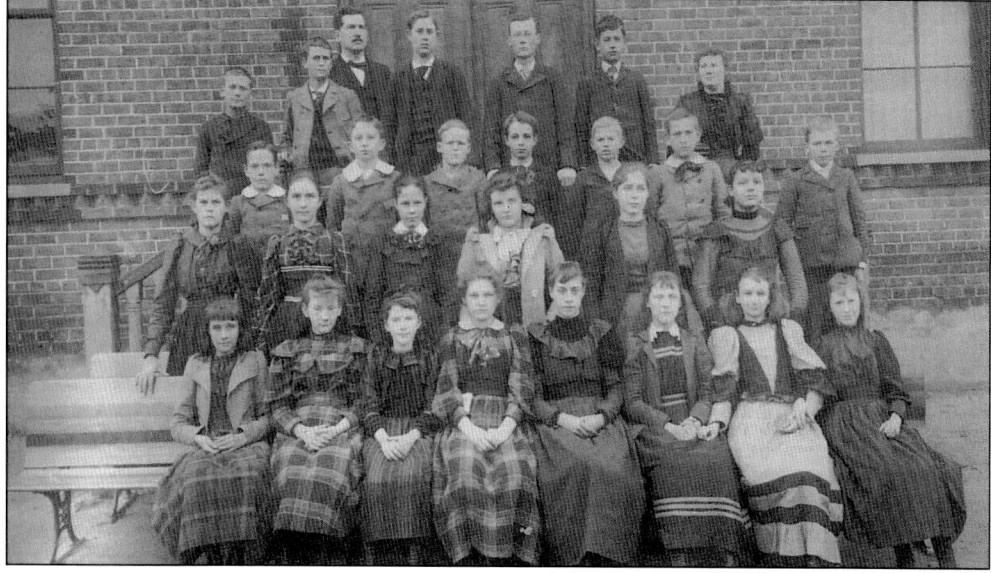

Primary and elementary students at Greensboro's new graded school for white children posed proudly for this 1895 photograph. Asheboro Street School (bottom) was completed two years earlier to accommodate the children living in south Greensboro, a rapidly growing area. It was designed in the Romanesque Revival style popular for educational institutions at the time. Black pupils attended private schools or Percy Street Graded School which opened in 1880.

Following the Civil War, Quakers in Philadelphia sent Yardley Warner to Greensboro to assist local black citizens. He purchased a 35-acre tract of land south of the town limits and sold half-acre lots to freedmen. A thriving community developed, and it was named Warnersville in his honor. Douglas Johnson, a postal clerk for the railroad, built his house at 803 Ashe Street around 1871.

St. Matthews United Methodist Church was organized by Warnersville residents in 1866 and is one of the oldest black congregations in Greensboro. Members built a simple frame church on Ashe Street at Lee Street and occupied it until 1904. A brick structure (left) replaced the original church, but the frame parsonage (right) remained. St. Matthews Church, damaged by the 1936 tornado, was removed in 1970 as part of an urban renewal project.

Bennett College began as a school in the basement of the Methodist church in Warnersville in 1873. In 1875, a 20-acre campus in east Greensboro was established, and a large building, named for benefactor Lyman Bennett of New York, was completed. Male and female students attended Bennett until 1926, when it became a college for women. This photograph of the student body was taken around 1890.

In the 1880s, neighborhoods were not as segregated as they came to be later, and black and white families lived in the same areas. Prominent white citizens remained in east Greensboro long after a black community developed around Bennett Seminary. In 1882, J.A. Odell, a leading businessman and benefactor, still lived at 313 East Washington Street in a house designed by Lyndon Swaim. By 1926, he had moved to West Market Street.

West Market Street, the site of Greensboro's earliest houses, continued to be a popular place to build. Early in the 20th century, A.W. McAlister, founder of Pilot Life Insurance Company, constructed this Queen Anne-style home in the 500 block between Edgeworth and Spring Streets. The McAlister children enjoyed their large home and lot close to downtown, and the boys (bottom) enjoyed many activities. This house, featured in the *Art Work of Greensboro* published in 1904, had been razed by 1925 when a YMCA was built on the site.

Around 1906, Spencer Adams, an attorney and Superior Court judge, built this 20-room house farther out West Market between Tate and McIver Streets. The Colonial-Revival residence featured a large porch with columns and balconies, a carriage entry, and bay windows. It was featured in the *Art Work of Piedmont North Carolina* published in 1924.

On February 19, 1961, the company hired to demolish this historic home held an "open house" so that people could visit for the first or last time. Many took advantage of this unusual invitation.

The J.W. Pugh House stood at 221 Church Street, beside the family grocery store at 219 Church and opposite the Presbyterian church that gave the street its name. When the house was razed in the 1970s, the family donated part of the land to provide parking for the Greensboro Historical Museum. The City of Greensboro now owns the property, and parking for the museum has been relocated.

John Alexander Gilmer, a Civil War veteran, lawyer, and judge, lived in this large Victorian house at the end of Elm Street. He married Jesse Lindsay's daughter and acquired the land from the Lindsay family. In order to extend Elm Street through the property in the 1880s, the Gilmer house was moved to 302 North Elm.

In 1887, the citizens of Greensboro passed a $100,000 bond issue that provided funds for streets, water and sewer lines, electric lights, and expansion of the cemetery and schools. North Elm Street, only two blocks long at the time, was extended to Bessemer Avenue, the northern limit of the city, in 1891. This postcard view captures some of the newest homes in this growing neighborhood.

John Walker Fry, who married Annie Gray, one of John Motley Morehead's granddaughters, built his Victorian mansion at 302 North Elm Street and lived there until 1916. His son-in-law, Pierce Rucker, acquired the house at that time, and the Ruckers were there until 1934. The Fry House is featured in the 1904 *Art Work* series, and it appears as the Rucker House in the 1924 version shown here.

The growth of area colleges also encouraged residential development. New Garden Boarding School, established by the Quakers in 1837, became Guilford College in 1888, and a town grew up around the school. Founders Hall, as photographed by Sidney Alderman around 1892, was a focal point for the campus from the beginning. Renovations through the years included adding a third floor, porches, and trim. Founders Hall was razed in 1973.

In 1891, the North Carolina General Assembly created the State Normal and Industrial School to educate young women to teach and work in office settings. Greensboro citizens put together a successful bid package, and the selected site between West Market and Spring Garden Streets stimulated growth in the area. The school (now UNCG) opened on October 5, 1892, with 176 students. Early buildings included Main Building (right), which was listed on the National Register in 1980.

Summit Avenue looking West, Greensboro, N. C.

Residential expansion to the northeast is associated with the arrival of the Cone and Sternberger brothers in the 1890s. They built textile mills and employee villages in the area, as well as their private residences. Summit Avenue, originally an access road through the property, became "a magnificent boulevard soon to be graded and macadamized" by 1898. This postcard view includes the 1902 streetcar tracks and two Sternberger homes.

In 1893, the Agricultural and Mechanical College (now North Carolina A&T State University) opened in Greensboro on a site northeast of Bennett College. Chartered by the state in 1891, the school was temporarily located in Raleigh. President J.O. Crosby designed Dudley Hall, named for A&T's second president James B. Dudley. Students laid the bricks that were made on campus. The building, photographed in the 1920s, burned in 1930.

Churches were important neighborhood gathering places. The congregation of Providence Baptist, organized in 1866, originally met under a brush arbor on its East Market Street site. An 1871 frame building was used for worship and as a school until 1876, when this sanctuary was completed. It was the first brick church for blacks in North Carolina. Razed as part of a 1964 urban redevelopment project, it was replaced by a new church on Tuscaloosa Street.

The brick sanctuary for St. James Presbyterian Church, pictured here, was completed in 1910 and used until 1958 when a new church on Ross Avenue was completed. The congregation began informally in a house on North Forbis Street and organized in 1868 when 30 black members of First Presbyterian requested transfers to the new church. St. James also used its church facility as a school, enrolling 150 pupils in 1875.

Local Episcopalians built their first church in 1871, and named it St. Barnabas. Designed in the Gothic-Revival style, the building stood on the northwest corner of Greene and Friendly until 1900, when it was moved to Elm and Paisley. Ten years later, this congregation and another parish merged to form Holy Trinity. The new congregation built a chapel at the corner of Greene and Fisher around 1922. The 1871 church was deconsecrated in 1930 and later razed.

St. Agnes Roman Catholic Church was completed in 1877 and stood on Forbis Street behind First Presbyterian and beside the early graded school. The parish outgrew this simple frame building and moved to a larger church on North Elm at Smith Street in 1899. St. Benedict's, the new parish, sold its old church to the city to be used as a public high school for white students.

Centenary Methodist Church was established by West Market Street Methodist in 1884 to minister to the residents of South Greensboro. Its name came from its creation in the centennial year of American Methodism. A small building on Arlington Street was used from 1885 until 1905, when the sanctuary pictured was completed at the corner of Asheboro and Arlington. Following neighborhood changes, the congregation relocated to Friendly Avenue in 1960. Miss Emma Weaver taught this elementary Sunday school class, photographed around 1912.

Another South Greensboro church, Westminster Presbyterian, dates back to 1883, when a small group of worshippers began gathering for services. The congregation, a mission of First Presbyterian, chose its name in 1887 and built this sanctuary around 1913. Constructed of cream-colored bricks, the building had wood paneling and a powerful organ. When Westminster moved to west Greensboro in 1959, Wells Memorial Church of God in Christ occupied the building until 1985. The church was razed around 1987.

In 1892, the congregation of First Presbyterian completed a new sanctuary on its Church Street property. Built in the Romanesque Revival style, it featured a tower, dormer windows, and arched entries. A portion of Lindsay Street School is visible on the left in this photograph made around 1895. This sanctuary is the oldest portion of the complex which now houses the Greensboro Historical Museum.

Greensboro's first congregation of Lutherans was made up of black citizens who began worshipping in the Warnersville community around 1893. In 1897, the Evangelical Lutheran Grace Congregation organized and dedicated a small sanctuary that was used until it burned in 1928. Merging with Luther Memorial Church, established in 1924, the new congregation built the sanctuary shown here at Benbow and East Washington Streets in 1930. (Copyright CM.)

The Church of the Redeemer congregation traces its beginning back to 1906, when a mission for black Episcopalians was first discussed. Three years later, an Episcopal Mission was established with approximately 12 members. This church, erected at the corner of East Market and Dudley Streets, was used until 1954 when it was condemned by the city for urban redevelopment. A new church on East Friendly was dedicated in 1967.

The original congregation of Greensboro Methodists built its third and final sanctuary in the 300 block of West Market Street in 1893. The church, now West Market Street United Methodist, was listed on the National Register in 1985. Designed in the Romanesque Revival tradition used for the 1892 Presbyterian church, this sanctuary features beautiful stained-glass windows purchased at the 1893 Chicago Exposition.

Spring Garden M. E. Church, South, Greensboro, N. C.

West Market Street Church sponsored a mission in the neighborhood that grew up around UNCG. This postcard view of Spring Garden Methodist Episcopal Church, now College Place, was made around 1908 when a new brick and stone church replaced the original chapel. This Tate Street structure is part of the current complex that includes a sanctuary constructed at Tate and Spring Garden Streets before 1920.

By the end of the 19th century, West Market Street featured a mix of houses, churches, schools, and businesses. This postcard also includes the elm trees that were planted in 1840 at the direction of the town commissioners. The Paisley House (left) and the Hill House (right) date from the town's early years, while the Methodist church with its massive bell tower represents new construction.

The Charles H. Ireland House (602 West Friendly Avenue) is another example of new construction that began in 1896 and was completed in 1904. The future of this National Register property, severely damaged by fire in February 1996, is uncertain. Described as Greensboro's "most flamboyant house," it was constructed of yellow brick and granite with shingles, slate, and stained glass as accents.

Three
A New Century
(1901–1920)

By 1901, Greensboro residents, numbering slightly more than 10,000, could boast 1.5 miles of paved roads and 2 miles of cement sidewalks. Still a city where many walked to work and shop, new means of transportation were just on the horizon. The city limits covered 4 square miles, with the western border near UNCG, the eastern border beyond A&T, the northern border at Bessemer Avenue, and the southern border at Whittington Street. The 1904 City Directory listed 29 churches; a 1903 business report estimated 50 manufacturing firms; and the school system advertised that its four elementary schools were operating on two shifts. In this photograph, J. Rankin Thomas, an officer with the American Realty & Auction Company, posed with his son Guy in their new automobile. The imposing family home at 219 East Market Street is in the background.

Edgeworth Street, created between the grounds of the Belle Meade and Weir estates, was named for the former school founded by John Motley Morehead. It became a popular address for a number of prominent men, including Leon J. Brandt. His home at 411 Edgeworth was included in the 1904 *Art Work* series. Brandt, Greensboro's mayor from 1907 to 1909, is credited with bringing the "Patriots," a professional baseball team, to the city in 1902. A number of Brandt descendants posed on the porch steps for this 1930s photograph.

Merchant J.C. Bishop built his Victorian house at 324 North Elm Street in time to be included in the 1904 *Art Work* series. In 1925, Bishop Street (now part of Lindsay Street) was cut through his property, connecting Elm and Lindsay. The house was razed and the street name disappeared, but, in 1951, the Bishop Block was created as a one-stop shopping center. The new Wrangler headquarters now stands on that site.

A special collection, featuring local houses photographed by J.C. Leonard around 1912, was donated to the Greensboro Historical Museum in 1983. Among the images is this one of the Jeter House on the southeast corner of Library Place at Gaston Street. Today, the address would be Commerce at Friendly. Mrs. Jeter operated a popular boardinghouse across the street from the Carnegie Library that was completed in 1906 and razed in 1951.

55

The Thomas A. Hunter home at 741 Pearson Street and the L.H. Cartland home at 109 Price Street were also featured. The Hunter House (top) at the corner of Pearson and Lee in South Greensboro was designed in the Colonial Revival style. The more modest Cartland House (bottom) featured elements of the Queen Anne style. It was located on Price Street that ran west of the 400 block of North Elm but no longer exists.

56

The construction of new buildings often required the razing or moving of earlier homes. By 1910, the Elks Club, designed by local architect F.A. Weston, had replaced the Robert Lindsay House on the southeast corner of Sycamore and Greene Streets. The house, long the residence of Miss Lizzie Lindsay who taught in the public schools, was moved behind the club to face South Greene, then razed around 1940.

The residence of merchant A.V. Sapp at 400 South Edgeworth, also in the Leonard series, was a wonderful example of a Queen Anne-style house. Typical features include its asymmetrical design, varied materials and shapes, the square tower, projecting bays, the wrap-around porch, and the entry swag. Members of the Sapp family gathered on the porch for this photograph.

This postcard view of South Park Drive captures the early character of a neighborhood first promoted by Basil J. Fisher in 1889. It remained a rural area until after 1902 when Fisher donated a tract of land to the city to become a park. The completion of the streetcar line also increased interest in the neighborhood. Fisher Park became Greensboro's first historic district in 1982, and the district was listed on the National Register in 1992.

The John M. Galloway House at 1007 North Elm, one of Fisher Park's most outstanding properties, was listed on the National Register in 1983. Designed by local architect Harry Barton and constructed under the supervision of stonemason Andrew Schlosser, the mansion was noted for its chocolate mortar and trim and a ballroom on the top floor. The house was completed in 1919, and Galloway died of appendicitis three years later.

Charles W. Gold moved to Greensboro in 1912 with Jefferson Standard Life Insurance Company, a firm he helped organize in 1907. He built this handsome home at 817 North Elm around 1917, when he was treasurer of the growing insurance company. Built in the Mediterranean-Revival style, it is included in the 1924 *Art Work* series. Special features include the separated front and side porches with top decks and a hipped roof. Built of tan bricks with green as the accent color, the house survives as the Howard Apartments. Lindley Nurseries provided the landscaping, and notes on a company photograph state: "This grouping of shrubs and trees in the back yard gives a distinct sense of privacy. It can be reproduced almost anywhere at slight cost."

The Latham-Baker House at 412 Fisher Park Circle was constructed in 1913 for James Edwin Latham, a cotton broker and real estate promoter. Wells Brewer of Greensboro designed the residence in the Prairie style made famous by Frank Lloyd Wright, and stonemason Andrew Schlosser constructed the granite walls. R.W. Baker, a Blue Bell executive, acquired the house, and his widow left it to Holy Trinity Church in 1981. The house, listed on the National Register in 1982, has been divided into condominiums with matching units built closeby. This photograph was taken around 1949. (Copyright CM.)

Not as fortunate was the residence built for attorney Edwin J. Justice around 1909. It stood on the northwest corner of Florence Street and Fisher Park Circle until it was razed in 1977. The Rypins Religious School of Temple Emanuel replaced the Justice House.

The Fisher Park neighborhood, bordered by Church Street on the east, Green Hill Cemetery on the west, Battleground Avenue on the south, and Wendover Avenue on the north, included modest housing also. Examples are the Thomas Crabtree House (top) at 309 Isabel Street and the A.F. Stevens House (bottom) at the intersection of Olive and Hendrix Streets. Crabtree, a cotton broker, used a modified Dutch-Colonial style for his house built of stone and shingles. Stevens, the manager of the insurance department of Banks-Richardson & Company, built a one-and-a-half-story bungalow that featured a wide gabled dormer. Both houses had porches, a common feature throughout Fisher Park.

Ceasar Cone moved to Greensboro in the 1890s and built a substantial house for his family that was featured in the 1904 *Art Works* series. It stood in a heavily wooded area south of Proximity Cotton Mill which was within walking distance. Cone also organized the Summit Avenue Building Company to develop a middle- and upper-class neighborhood along the new street. The land east of Summit was a farm that provided milk and meat for the family. The original house was replaced with a more impressive one in 1914, and this mansion (bottom) was razed in 1962, following Mrs. Cone's death. The Cone grounds were beautifully landscaped, and some of the trees and shrubs are still visible. The neighborhood developed by Ceasar Cone became the Charles B. Aycock Historic District in 1984, and the name was taken from Aycock School that was built in 1927.

Summit Avenue became a major road into Greensboro and as commercial establishments were built, it lost its residential appeal. Around 1945, the Oscar L. Sapp House at 421 Summit was moved to 660 Chestnut Street. Sapp, an attorney for many years, purchased the house from Dr. G.W. Hughes and lived there from 1912 until 1945.

This simple bungalow at 605 Park Avenue in the Aycock Historic District is significant because of the family who lived there. In 1921, Mr. and Mrs. George Earl Preddy built the house where their four children grew up. George Preddy Jr. (1919–1944) joined the Army Air Force in 1940 and was America's leading air ace at the time of his death. He attended Aycock and Greensboro High Schools, as well as Guilford College, before enlisting.

Pleasant D. Gold, an officer in the Goose Grease Liniment Company, built his home at 1020 West Market Street in 1904. Designed by local architect J.H. Hopkins in the Shingle style, it appeared in the *Art Work* series published that year. The house features three roof types and a polygonal corner tower. By 1906, Charles Kellenberger had acquired the residence, and during the Depression his family began taking in boarders. The boardinghouse evolved into the Shady Lawn Motel with 27 rooms that accommodated 54 customers. Expansions included an annex facing Friendly Avenue and a second house on West Market. Charles Kellenberger Jr. operated the motel from the late 1940s until it closed in 1983. Shady Lawn was one of the first local motels to have television sets and telephones in every room. Currently the building houses a UNCG fraternity.

This Colonial-Revival-style house appears in both the 1904 and 1924 *Art Work* series, under construction in the first and completed in the second. Built by Dr. J. Pickney Turner, the medical director for Jefferson Standard Life Insurance Company, it stood at 615 West Market Street. When the house that had become headquarters for Moore Music Company burned in the early 1970s, it was replaced by a commercial building still in use. (Bottom photo, copyright CM.)

Some College Hill houses were razed to make room for churches and schools. The Ezekiel Pool House at 824 Walker Avenue stood on a lot needed to build the Church of the Covenant. Other houses were removed for First Baptist Church, Weaver Education Center, and the YMCA. Current structures are better protected, because the neighborhood became a historic district in 1980 and was listed on the National Register in 1993.

Members of First and Westminster Presbyterian Churches organized a new congregation on May 18, 1906. Its mission was to serve God, its membership, and the community that had developed around Greensboro College and UNCG. A sanctuary, constructed at the corner of Mendenhall Street and Walker Avenue, was used from 1906 to 1914. It was moved and replaced by the 1914 sanctuary that is still in use.

A.K. Moore moved to Greensboro around 1914 to manage the real estate department of the Guilford Insurance and Realty Company. After selling property in Fisher Park, he decided to organize a west Greensboro neighborhood which he named Westerwood. Its borders were Lake Daniel Park and the city waterworks on the west and north, the railroad on the east, and Guilford Avenue on the south. A plat map with many lots already sold was filed in 1919, and every house in the development sold within a year. Moore promoted the area with a demonstration house that was open to the public and by serving watermelon to visitors. These two houses on North Mendenhall Street were built in the 1920s. Salesman B.C. Blanks occupied the one at 507 (top) by 1928 and dentist T.E. Sikes occupied the one at 208 (bottom) from 1922 until 1928.

In 1911, Southern Real Estate Company formed the Irving Park Company and announced the creation of one of Greensboro's most successful real estate developments. The focal point of the 350-acre project was a nine-hole golf course and country club. In 1913, a promotional brochure (top) promised house sites of certain sizes and city services, including streetcars, water and sewer lines, fire hydrants, underground telephone lines, sidewalks, and "no bill boards, no pigs, no nuisances, and no front fences." The gates at Sunset and North Elm (bottom) also served as covered trolley stops, and Lindley Nurseries provided the entry landscaping as shown in this company photograph. The William B. Vaught House at 108 Sunset Drive, completed around 1916, is visible on the right.

This postcard view of Sunset Drive features three of the neighborhood's earliest houses built by the Mebane brothers, insurance executives, and Aubrey L Brooks, general counsel for Jefferson Standard Life Insurance Company. The winding street is typical of those built in Irving Park to accommodate automobiles and the hilly terrain. John Nolen, a noted landscape architect from Cambridge, Massachusetts, drew the master plan.

In 1918, Philadelphia architect Charles Barton Keen designed a 12,000-square-foot house for A.W. McAlister that was unlike any other Greensboro residence. His horizontal form featured multiple doors and windows opening to the outside and projecting wings with porches. The owner placed the house on a 12-acre lot and named it Homewood. The McAlister family left downtown to live in Irving Park but returned to Greene Street in 1951.

Charles Barton Keen also designed the William Y. Preyer House at 603 Sunset Drive. Like the McAlister House, it has a horizontal shape with wings at each end. The house was built around 1924 for Preyer, an executive with Vick Chemical Company, and it is still occupied by Preyer descendants.

The Irving Park house constructed for A.M. Scales was very different from the Georgian Revival homes designed by Charles Barton Keen. Charles Hartmann, a local architect, chose a style that combined Prairie and Mediterranean elements for Scales, one of the neighborhood's major developers. This house at 1511 Allendale Drive was completed around 1922, and Scales lived there until he moved to a new home in Hamilton Lakes.

Aubrey L. Brooks, an attorney and insurance executive, commissioned New York architect A. Raymond Ellis to design "The Poplars," one of the earliest houses in Irving Park. Ellis used the Neoclassical Revival style for the brick mansion that stands at 409 Sunset Drive facing Greensboro Country Club. The Brooks House has been photographed many times, and Carol Martin took the image used here (top). The house appears in the background of the bottom image that features the staff of an earlier photographic firm, The William A. Roberts Film Company. (Copyright CM.)

71

Prominent citizens lived in houses scattered throughout Greensboro, as well as in the new neighborhood to the north and west. Tobacco merchant John W. King built his residence at 314 North Church Street, and it was one of the area's first Tudor Revival-style structures. The King House had 12 large rooms, including a third-floor billiard room. In the 1960s, the house was converted to a private club that served gourmet meals and fine wines, and for more than 20 years it housed Jung's Chinese Restaurant. Jung's closed in 1982.

The Queen Anne-style home of Clara J. Peck stood at 524 Douglas Street in South Greensboro. The owner came to America from England in 1872 when she was ten and to Greensboro in 1898. Widowed early, she turned to nursing as a means of support, and, in 1909, the District Nurse and Relief Association was established to fund her efforts to help the needy. Many people attended Mrs. Peck's funeral held in her home on June 15, 1926.

The Glenwood neighborhood was created early in the 20th century with boundaries at Freeman Mill Road (east), Aycock Street (west), Florida Street (south), and Lee Street (west). The streetcars ran through this middle-class development which included houses, churches, factories, schools, and stores. The first services at Glenwood Presbyterian Church (top) were held on November 8, 1914. The sanctuary, formerly used by the Church of the Covenant, had been moved to the corner of Glenwood Avenue and Oak Street. Damaged by fire in 1943, the sanctuary was rebuilt and remodeled. The Glenwood Park Sanitarium (bottom) for patients with nervous and mental conditions was another prominent building. It succeeded the Telfair Sanitarium founded in 1903 and was succeeded by the Crawford Treatment Center in 1978. A modern brick building replaced this residential-style facility.

In 1911, the Greensboro Board of Education, chaired by Charles H. Ireland, held a ceremony to lay the cornerstone for Central High School. This facility on Spring Street replaced the one on Forbis Street and was used by white high school students until 1929. At that time, it became a junior high. The architectural firm Hook and Rogers of Charlotte designed the school that stood on the site now occupied by Weaver Education Center.

The sale of school bonds provided funds to construct Ashe Street Graded School in 1910. Located between Whittington and McCulloch Streets, it was Public School #2 for black children. Rev. Silas A. Peeler, for whom Peeler Elementary School is named, served as principal of the school for a brief time. This photograph was taken around 1912. The board of education did not provide a high school for blacks until 1925.

The day set aside to take school pictures was always an important one, but the early photographs in museum archives are of classes rather than individuals. According to the slates in these photographs, one group (top) is the junior class in 1918, probably at Central High School, and the other (bottom) is a 1918 class at Asheboro Street Graded School.

The 1902 completion of the trolley system by the Greensboro Electric Company spurred residential development in several areas. J. Van Lindley provided land at the western end of the line for the company to build an amusement park that included a pavilion, artificial lake, casino, and bowling alleys. When the amusement area closed in 1917, Lindley donated 40 acres farther west to become a city park. Landscape architect Earle Sumner Draper designed the park (top) and some of the surrounding subdivisions. Located between UNCG and the Pomona community, Lindley Park became a popular neighborhood that included schools, churches, houses, stores, and factories. College Park to the east and Highland Park West were developed in the 1920s as neighboring communities.

In 1911, Francis and Frances Nicholson moved into this new house at 2400 Walker Avenue in Lindley Park. The family included three children, a daughter, Mary, born in 1905, and two younger brothers; two more sons were born in 1914 and 1923. Mary attended Guilford College and UNCG but moved to Ohio without graduating. She learned to fly before returning to Greensboro and earned her pilot's license in October 1929. Mary became the first licensed female pilot in North Carolina, and, in 1941, she helped organize the American Women for the Air Transport Authority (ATA). The following year she went to England as an ATA flier. On May 22, 1943, while delivering a plane for the Royal Air Force, she died in a plane crash. One of 38 American women fliers to die in WW II, her achievements were recognized when Greensboro celebrated February 12, 1944, as "Mary Webb Nicholson Day."

77

In the 1870s, J. Van Lindley developed a community that he named Pomona for the Roman goddess of fruit trees. There he expanded the nursery business inherited from his father, making Lindley Nurseries the largest in the state. Proximity to the rail lines made it possible to ship plants to many destinations. Lindley was also a founder of the Pomona Terra Cotta Company (1886) and a director of the Pomona Cotton Mill (1897). By 1900, the neighborhood included approximately 1,000 employees and executives.

Among the photographs in the Lindley Collection at the museum is this one of J. Van Lindley outside his home at Pomona. These notes are written on the back: "Beds of Retinsboras (or Japan Cypress) in front. Japan Varnish tree partly showing at right. The building with assorted shrubbery around foundation is the Company's office."

Lindley's only son, Paul, also lived at Pomona in a Queen Anne-style home facing the railroad tracks (top). Company president by 1919, he also was involved in many civic causes. Paul worked to develop the airport that began as Lindley Field, promoted recreational facilities, including Country Park, and served eight years on city council, including a term as mayor from 1931 to 1933. A photograph of the home of A.J. Sykes (bottom), general manager of the Lindley company, includes these notations: "Norway maple is in front of house; just in front of the door are evergreens; assorted shrubs around porch; small Japanese maple to right of drive; Blue Spruce on left."

In 1901, the congregation at First Presbyterian announced plans to erect a Sunday school building and hired Hook and Sawyer of Charlotte as architects. Site work began in April 1902, and construction was completed in 1903. The detached building, named in honor of former minister J. Henry Smith, was used until the congregation moved to Fisher Park. This photograph includes the new building and the manse that stood south of the sanctuary.

First Baptist Church moved into its fourth building on the northwest corner of Market and Eugene in 1906. This postcard shows the new church and the Methodist church in the next block. Winningham & Fries designed the sanctuary that cost $55,000. The Baptists built a new church in 1951 and sold this building to First Lutheran Church. It was that congregation's home until 1969, when it was razed to widen West Market Street.

The first worship service for Greensboro Lutherans was held in October 1907, and 21 charter members formally organized the congregation of First Lutheran Church in 1908. The first sanctuary was erected on Ashe Street in 1911 and used until 1953, when the congregation purchased the Baptist church on West Market. By that time, the membership had reached 400. First Lutheran relocated to 3600 West Friendly Avenue in 1969. (Copyright CM.)

First Reformed Church, established in 1903, occupied a sanctuary at the corner of West Lee and South Spring Streets through the 1920s. This postcard rendering was very similar to the building actually constructed. The congregation is now Peace United Church of Christ on West Market Street.

This postcard (top) of Main Building at Immanuel Lutheran College was made after 1905 when the school relocated in Greensboro. Established in Concord in 1903, its purpose was to serve the spiritual and educational needs of North Carolina blacks. Immanuel Lutheran provided three levels of education: a high school, junior college, and theological seminary. Although many local students attended the school, boarding students came from New York, California, and other states. Immanuel Lutheran was closed in 1961, when officials of the Lutheran church decided it was no longer necessary, but an active alumni association keeps its memory alive. Located on East Market at Luther Street, the school's Main Building was originally an exotic structure blending many architectural elements. Renovated at a later period, it became a basic stone building (bottom).

Four

GREATER GREENSBORO
(1921–1945)

This scene from the 1924 *Art Work of Piedmont North Carolina* captures the essence of Greensboro's early residential areas. Granite curbs, walls, and steps were common, since the material could be shipped from the granite works at Mt. Airy by railroad. Large houses, often covered with vines and sheltered by trees and shrubs, stood on spacious landscaped lots facing streets designed for horse-drawn wagons and buggies. Many downtown residents were beginning to relocate to the suburbs, now connected to the business district by streetcars and the increasing availability of automobiles. Others remained downtown, as did Irving Park developer Robert Vaughan, who lived in this house on Church at Smith Street. In 1923, the Jefferson Standard Building was completed and the city limits were extended to cover nearly 18 square miles and to include more than 43,000 people. Greensboro was changing with the times.

Downtown's old and new blend in this photograph which includes houses in the College Hill Historic District and the skyscrapers of the 1920s: the Jefferson Standard Building (left), the King Cotton Hotel (center), and the Guilford Building (right). People continued to build in College Hill during the 1920s, but the houses were usually more modest. Some were located on lots created between the earlier homes, increasing the neighborhood's density.

North Elm Street began to show transitional changes in the 1920s also. In this photograph, Smith Tire Company (409 N. Elm) stands beside a Queen Anne-style home. There are automobiles at the curb and trolley tracks in the center of the street, which has been widened to accommodate parking.

Greene was still a quiet residential street, isolated from downtown developments, in 1921. The 1903 water tower on Bellemeade Street was a familiar sight to the neighbors, but the Jefferson Building was a modern wonder. Greene was extended in the 1920s and is a major city artery today. The water tower, later moved to Wendover and Church Street, was razed in 1982.

West Lee was also a quiet residential street in the 1920s, when a firehouse was built for Engine Company #8 at 1737 West Lee. City funds, set aside to improve the fire department and to increase service to new neighborhoods, were used. A 1922 advertisement for Piedmont Heights, a suburb west of Glenwood with lots facing Lee, described the street as "one of the finest asphalt thoroughfares in or around Greensboro."

Many Fisher Park residences were constructed between 1915 and 1930. W.A. Hewitt, president of the Morris Plan Industrial Bank, built his Neoclassical Revival-style house at the corner of Elm and Fisher Park Circle in the early 1920s. Its features include a two-story portico and wings with sun porches. A note on this photograph from the Lindley Company files states that this is "an artistic arrangement of shrubs and trees for a corner lot."

The W.D. Meyer House at 200 Fisher Park Circle predates the Hewitt House by a decade. It was constructed on a prominent hill in 1913 for the owner of a downtown department store. Like many of his neighbors, Meyer chose the Georgian Revival style. Mr. and Mrs. Joseph Guill acquired the Meyer-Broadhurst House in 1955, and their descendants restored the 6,000-square-foot home in 1997. (Copyright CM.)

In 1928, Julian Price, president of Jefferson Standard Life Insurance Company, hired Charles Hartmann to design a home for him at 301 Fisher Park Circle. Hillside, a Tudor Revival-style mansion with 31 rooms, is 160 feet long and is surrounded by spacious grounds. In 1950, Ralph Price donated the family home to First Presbyterian Church to use as a manse. Purchased from the church in 1975, it was listed on the National Register in 1980.

A number of churches were also built in Fisher Park during the 1920s. Holy Trinity Episcopal Church, established in 1910 from two earlier congregations, commissioned Hobart Upjohn of New York to design its chapel. A Gothic Revival-style building was constructed in 1922. This photograph shows the matching sanctuary under construction in 1949. (Copyright CM.)

Hobart Upjohn also designed Temple Emanuel, the first structure in Greensboro built as a synagogue. Completed in 1923, the Temple's Neoclassical Revival style features a two-story marble portico. A Star of David is centered in the pediment over the entrance. Dedicated in 1925, the temple was used by all Greensboro Jews until a new synagogue formed in 1949.

Upjohn designed a third building for the congregation of Grace Methodist Protestant Church. Located at 438 West Friendly Avenue and built in the Colonial Revival style, Grace was completed in 1925. In 1939, the Methodist Protestant Church merged with the Methodist Episcopal Church and the Methodist Episcopal Church, South, to create The Methodist Church, now The United Methodist Church.

In 1927, First Presbyterian Church decided to build a new sanctuary in Fisher Park. The congregation commissioned Hobart Upjohn as architect with local architect Harry Barton as his assistant. Upjohn's Norman Revival design was unique for Greensboro. The church stands on a hill supported by a massive foundation, and the north wall has corner towers with a large rose window over the entry doors. The education building, a memorial to Jacob Henry Smith, provides classrooms, meeting rooms, and offices. Later additions (1959, 1962, and 1998) were designed to blend with the original structure. The cornerstone for this church was laid on September 30, 1928, and the dedication sermon was preached on October 6, 1929. First Presbyterian's former buildings were left vacant for nearly a decade, but, in 1937, Mrs. Lunsford Richardson, one of Jacob Henry Smith's daughters, and her three daughters purchased the buildings, donating them to the City of Greensboro. The family also provided renovation funds. Richardson Civic Center opened in 1939, and the building, now the Greensboro Historical Museum, was listed on the National Register in 1985.

Summit Avenue continued to be a prestigious address, and early houses were replaced with modern structures. Emanuel Sternberger built this home at 715 Summit (top), and his daughter, Blanche Benjamin, inherited it in 1928. Two years later, she converted the house to a hospital for women and children. When the hospital closed in 1953, the Guilford County Welfare Department moved into the building, using it until 1972. The house was razed in 1973, and the site has been developed as a memorial park. Harry Barton designed the Sigmund Sternberger House (bottom) that was completed in 1926. He used the Mediterranean Revival style for a villa, complete with tile roof and arcades. Sigmund moved his father's house to 732 Park Avenue to create a building site at 712 Summit. His house, now used as studio space for writers and artists, is listed on the National Register.

The A.J. Schlosser House (200 East Bessemer Avenue) features some of the architectural elements used for the Sigmund Sternberger House, including a green tile roof and rounded arches. Relative Andrew L. Schlosser, who worked on many local mansions, probably did the stonework. Completed around 1922, it was included in the 1924 *Art Work* series.

In 1922, the Greensboro school system hired a New York architectural firm, Starrett and Van Vleck, to design four new schools. The largest, named for Gov. Charles B. Aycock, was built at 811 Cypress Street. The elementary school, now a middle school, became the focal point for a new historic district created in 1984. (Copyright CM.)

Proximity Manufacturing Company, organized by the Cone brothers in 1895, emphasized the importance of education for employee families. Proximity Public School, the second by that name, was completed in 1928. Architect Charles C. Hartmann designed the building with an unusual stone and brick checker motif on the wings. Now McIver Education Center, the school is located at 1401 Summit Avenue. (Copyright CM.)

In the 1930s, East Lee Street ran through a quiet residential neighborhood, as shown in this photograph that looks to the west. The Church of the Nazarene at Arlington and Lee was built around 1931. The widening of Lee brought major changes to east Greensboro.

A positive change in the east was the development of the Nocho Park neighborhood that opened in 1928. Considered an exclusive black residential development, it included a 12-acre park, a hospital, and a high school. Although planned by a white real estate firm, it was named for J.R. Nocho, a prominent black citizen who died in 1914. Architect F.A. Mayfield designed many of the neighborhood homes, including this large house on Benbow Road, the neighborhood's major street.

In 1929, the city school system built its first high school for blacks and named it for James B. Dudley, A&T's second president. Charles C. Hartmann designed the building that was constructed at 1200 Lincoln Street in Nocho Park. A high school program, housed at Washington Street School from 1926 until 1929, flourished on this new campus. The class of 1930, the first to graduate from Dudley, is pictured.

Development in Irving Park continued throughout the 1920s and 1930s, although the Depression decreased the number of houses built each year. Philadelphia architect Charles Barton Keen designed this house on Granville Road for Smith Richardson, president of Vick Chemical Company, in the early 1920s (top). Its horizontal shape is similar to his other Irving Park designs, but the angled wings set it apart. In the 1913 promotional brochure for Irving Park some price guidelines were established to protect owners and to "not only maintain but increase values." This house at 307 Sunset certainly met its $5,000 minimum. Charles Hartmann designed it in the Colonial Revival style, and George Kane built it in 1925 for Lynn B. Williamson, a textile executive.

Textile giants J. Spencer Love and Herman Cone built two of the neighborhood's major residences in 1936. Love, founder of Burlington Industries, chose the Georgian Revival style for his 12,000-square-foot mansion at 710 Country Club Road (top). Ben Cone purchased the house in 1941 and lived there until 1977, when he sold the house to Love's son Richard. The house sold again in 1983 and 1997. William Holeyman of Greensboro designed the Herman Cone House (bottom) at 806 Country Club. Herman, the oldest son of Ceasar Cone, was then treasurer of the Proximity Manufacturing Company. This 17-room house remained in the family until the 1990s. (Courtesy of Love, copyright CM.)

The northwest corner of Irving Park, near the intersection of Elm and Cornwallis, contained more modest homes. The Elmwood Drive houses of B.C. Vitt at 215 (top) and E. Frank Andrews at 202 (bottom) are typical of those in the area. Photographer Carol Martin captured the Andrews house on February 21, 1947, following a major snowfall. The variety of houses in Irving Park is a neighborhood characteristic. (Andrews photo, copyright CM.)

C.C. Hudson, the founder of Blue Bell and a resident of Irving Park, commissioned Charles Hartmann to design a retreat for him. Hudson specified a log structure to be built in the proposed Kirkwood neighborhood. "Idlewood" was built in 1925 on a 100-acre site. In 1994, the property was purchased to create a cluster of houses in "The Village of Kirkwood." The log house was dismantled and reassembled in Alamance County.

Edwin and Blanche Sternberger Benjamin decided not to build a new house when they moved from Summit Avenue. The property they were developing off Friendly Road included an 1800s farmhouse that they remodeled and expanded. "Starmount Farm" also had a horse barn, lake, guest cottage, servants' quarters, and formal gardens. The Starmount Company moved the house to the western edge of Friendly Shopping Center in 1998.

The neighborhood around the college for women, now UNCG, continued to develop in the 20th century. The city built a firehouse for the West End Hose Company on Mendenhall Street that was replaced around 1920 by a new one (top). This Gothic-style station, located on the northeast corner of Walker and Mendenhall Streets, was converted to a residence in the 1960s. A new General Greene Service Station (bottom) was built at the corner of Tate and Walker Streets around 1928, and architectural elements were added to give it a residential flavor. The crowd is gathered to preview a new Chrysler automobile.

A small subdivision called College Park was developed west of UNCG in the 1920s. Its original borders were Aycock and Market Streets on the east and north, Walker Avenue on the south, and Mayflower Drive on the west. Kensington Road came to be the dividing line between College Park and a new neighborhood, Sunset Hills. This bungalow at 109 Kensington is typical of the smaller homes in the suburb, which included many large ones.

During the Depression, many local people were employed to work on federal projects, and, in 1933, the Civil Works Administration granted money to UNCG. In 1935, a nine-hole golf course was constructed on the western edge of the campus. A log building to be used as a golf club house was part of the plan. Later used for recreational programs, offices, housing, and storage, the house was sold and moved in 1990.

The A.K. Moore Realty Company developed Sunset Hills in western Greensboro beginning in 1925. The extensive neighborhood, just inside the new city limits, reached from Walker Avenue to Benjamin Parkway and from Aycock Street to Wendover Avenue. Both Market Street and Friendly Avenue (then Madison Avenue) were principal streets. This photograph (top) was taken at the intersection of Madison Avenue with Westover Terrace and Aycock Street before they were realigned. The area was protected by gates and deed restrictions. The postcard image (bottom) shows the proximity of the neighborhood to downtown. Sunset Hills included a park, winding streets with lush plantings, and a $5,000 minimum price guideline. Tudor Revival-style houses were very popular.

Advertising seemed to reach a new level in Greensboro after 1923. This 1931 professional display on North Davie Street combined lighted billboards and a sample product. One sign promotes the McManus Company (North Greene at Paisley Street) that sold new and used cars. The other advertises Green Valley Golf Course, a new public facility that made the popular game accessible to those who didn't belong to a country club. L.B. Leftwich developed the course on land leased from the Starmount Company, and Dugan Aycock was the first pro. Green Valley opened as a nine-hole course in 1928, closed in the early 1930s, and was reopened in 1948 by Aubrey Apple. It was expanded to 18 holes in 1954 and then became a private course. In 1984, Starmount announced the course would be replaced by an office park. Also visible in the photograph is the bell tower for the 1892 Presbyterian Church that had been abandoned for the new facility in Fisher Park.

Bessemer Avenue was originally part of the tract purchased by the North Carolina Iron & Steel Company in the 1880s and by the Cone brothers in the 1890s. It marked the northern limit of the city in 1891 and became the northern section of Fisher Park. In the 1920s, it ran through a neighborhood with curving streets, well-landscaped yards, and modest bungalows, as seen in this postcard view (top). G.C. Cox, secretary-treasurer of Gate City Motor Company, lived on the corner of Bessemer and Virginia before he moved to College Park in 1925. Lindley Nursery landscaped his yard and used this photograph to illustrate its work.

Carolina Street began at Hendrix Street and crossed Bessemer and Wendover before it ended in Latham Park. Harold Schiffman, who operated the family jewelry store with his brother Arnold, lived at 902 Carolina, south of Bessemer. His house (top) was built around 1930 and stood beside the earlier Hill Hunter house. Both were typical Fisher Park homes. North of Wendover the character of the street changed. J.S. Oakes, a textile worker who lived at the corner of Carolina and Northwood, opened a sandwich shop and grocery store in his yard in 1940. The Greensboro Overall Company was across the street and provided customers. In the late 1920s, Latham Park, a 70-acre tract, was created between Fisher Park and Irving Park with Briarcliff and Hill as principal streets. The newspaper described it as "a place where you can get out in your shirt sleeves and stretch if you feel like it."

West Market Terrace, first laid out in 1913 as Morningside Heights, was finally developed in the 1920s. Its borders were East Lake Drive, West Market, Westover Terrace, and Benjamin Parkway. The 1926 City Directory lists this house on the northeast corner of Market and East Lake as the residence of architect C. Gadsden Sayre. In this photograph it is identified as Lake Manor, a facility for travelers who needed rooms.

Garland Daniel laid out a new development north of Benjamin Parkway in 1926. House sites were situated around a park and man-made lake. Early brochures state that "Daniel's Lake . . . provides wading and bathing" and describe the neighborhood as "Close to the Heart of Nature and to Greensboro." A mile west of downtown you could find "not only a romantic setting for your home, but comfort, convenience, and surcease from congested sections."

Around 1928, the city built a reservoir on land it acquired when the Lake Daniel developers had financial problems. For many years the fenced lake was an attractive place for community gatherings, but, as Greensboro's water needs increased, a less-attractive filter plant (top) was added. In the early 1980s, the city considered selling its property in Lake Daniel, but a concentrated effort by citizens resulted in a decision to keep the land as a city park. A focal point for the neighborhood from the start was "Greater Greensboro's Million Dollar High School campus." Charles Hartmann designed Greensboro Senior High (GHS) which opened in 1929. The school was renamed for George A. Grimsley, a former school superintendent and board chairman, in 1962. This photograph of GHS supporters (bottom) was taken on November 14, 1945. (Copyright CM.)

The former Pomona High School (top) was built around 1920 on the southwest corner of Spring Garden and Bruce Streets in Lindley Park. It replaced two earlier frame buildings and was one of the first large consolidated schools in Greensboro. Renamed for J. Van Lindley in 1929, it became Lindley Junior High. This classical building, now listed on the National Register, was converted to apartments in the 1990s. On May 19, 1923, the Pomona High School baseball team won the state championship, beating Durham High School 5-0. Ed McBane (left) served as coach.

A.M. Scales, a principal developer of Irving Park, turned to west Greensboro for his next project. When the community was incorporated as the town of Hamilton Lakes in 1927, he became its first mayor. The site included three man-made lakes, and the first houses were built on lakeside sites. A proposed golf course was the southern boundary, and a well-landscaped park was an important feature. The land was cleared with workmen using mule-powered equipment. This development, heavily mortgaged by the managing company, came under the control of the Edward Benjamins in the late 1920s. When the Town of Hamilton Lakes merged with Greensboro in 1957, it was guaranteed zoning protection and continued private use of recreational facilities. Much of the building in Hamilton Lakes occurred after WW II.

Scales moved from Irving Park to a new home west of the city limits in 1926. Designed in the Neoclassical Revival style by Greensboro architect C. Gadsen Sayre, the house sat on a 12-acre site overlooking Lake Hamilton. Scales named his estate "Descaler" and planted the grounds with thousands of rose bushes, ferns, and trees. This house, one of the largest in Guilford County, features 11-foot ceilings, a reception hall with hand-painted Italian wallpaper (bottom), a call box for servants, nine bedrooms on the second floor, and six bathrooms. Scales got into financial difficulty in the late 1920s, and a Richmond bank acquired the house. Junius Smith, who purchased the mansion from the bank, later sold it to H.L. Coble. Robert Dinkle, founder of Carolina Quality Block and Concrete, bought the house in 1950 and lived there until his death in 1989.

In April 1926, Scales offered a prize of $3,500 for the most attractive home started in Hamilton Lakes during the year. His next advertisement for "The Town by the Smiling Waters" included a sketch of the Joseph R. Morton House and a caption: "the home is one of the latest to be eligible for the thirty-five hundred dollars." The Morton House, like the Herman Cone House in Irving Park, combines the Tudor Revival and French Eclectic styles. It faces Kemp Road West and Lake Euphemia. William Lamdin, a Baltimore architect, designed the house, and Ruth Morton laid out the grounds and formal gardens. Joe Morton, a Greensboro native and founder of a chemical company that merged with the Charles Pfizer Co. in 1958, lived in the house until his death in 1994. Carol Martin took these photographs in 1945 and 1947. (Copyright CM.)

Edward and Blanche Sternberger Benjamin acquired hundreds of acres in western Greensboro following the failure of the Hamilton Lakes development company and the death of Emanuel Sternberger who held many of the company mortgages. In 1930, the Benjamins decided to develop an area east of Hamilton Lakes that they named Starmount, a loose translation of the name Sternberger. During the decade winding streets were installed, sites were cleared, and a few houses were constructed. Manpower and mule-power were used to create roads and bring in materials (top). The informal boundaries of the sprawling neighborhood are Green Valley Road on the east, East Kemp Road on the west, Starmount Drive on the south, and Friendly Road on the north. This well-known sign stands on West Market which is crossed twice by Starmount Drive.

The Starmount Company with Moore & Turner as agents marketed the development in various ways. In April 1939, they advertised "The Talking Home" to attract potential customers. Similar to the house pictured, it was described as follows: "On a wide, spacious home site with an unobstructed view of the picturesque parks of Starmount Forest, there has been built a new home of true Williamsburg Colonial design. The decoration of the home is superlative—the design outstanding. If you would like to see a home that is as modern as the morning, come out while this Talking Home is open for inspection. There is a tremendous recreation room, light airy bedrooms, and a kitchen that is the last word in convenience and equipment. Here is a home that was really 'Designed for Living—Built to Endure.' " The ads also noted that each deed guaranteed protection from "undesirable encroachments."

The Starmount Forest golf course, designed by Styles & Van Cleek in consultation with Donald Ross, opened on August 1, 1930. Edward Benjamin began construction of this 18-hole championship course in a pine forest in 1929, because he knew it could attract residents to the rural development. Originally a public course, it became Greensboro's second private one in 1937. This aerial view (top) was taken in 1946. From 1938 until 1961, the Jaycees' Greater Greensboro Golf tournament (GGO) was held at Starmount and Sedgefield with play alternating by the day or by the year. Starmount hosted the first round in 1938. In 1977, the GGO moved to Forest Oaks Country Club. (Aerial picture is copyright CM.)

The original Starmount clubhouse featured on this postcard includes a ballroom wing and golf shop that were later additions. The building burned in 1956, and a new club replaced it the following year.

Many of the original Starmount houses were modest, one-story versions of Colonial or Tudor Revival styles, priced to attract young, growing families. Recreational facilities and open spaces for activities were important neighborhood amenities.

Sedgefield, the second residential project of the Irving Park developers, was located approximately 7 miles southwest of Greensboro. It was the first neighborhood linked to downtown by a highway, rather than a trolley line or street. The investors purchased more than 3,000 acres from John Cobb's estate in 1923 and began implementing a plan that included fine houses, a golf course, tennis courts, a horse show arena, and a resort hotel. The Sedgefield Inn opened in 1927, and many of its patrons came to play golf or participate in horse shows. In 1931, the financially troubled Southern Real Estate Company sold its holdings at public auction, but Sedgefield continued to be a desirable neighborhood with much of its growth coming after WW II. In 1953, a group representing North Carolina's colleges and universities met at the Sedgefield Inn

to discuss forming an athletic conference. Eight schools joined the Atlantic Coast Conference (ACC), and, in 1954, the conference office was established in Greensboro. During the 1960s, Sedgefield Country Club acquired the inn which was replaced by a new facility in 1993.

Equestrian activities were an important part of life at Sedgefield. Horse shows involved the community, and the Sedgefield Hunt Club held an annual event. (Copyright CM.)

In 1925, Donald Ross, designer of the Pinehurst course, prepared plans for two 18-hole golf courses to be built at Sedgefield. The Valley Brook course was completed by the newly organized country club in 1928, before economic problems slowed the development at Sedgefield. The first GGO opened at Starmount and ended on the Sedgefield course with Sam Snead posting a score of 271, 11 strokes under par. He won $5,000. From 1961 until 1976, when it moved to Forest Oaks, the GGO was played exclusively on Sedgefield's upgraded par 71 course. Although women enjoyed playing on their neighborhood courses, club rules often restricted female play to certain hours and certain days. Carol Martin caught this Sedgefield foursome at rest. (Copyright CM.)

Five

THE MODERN CITY
(1946–PRESENT)

Today the intersection of North Elm Street and Cornwallis Drive is one of Greensboro's busiest, especially in the mornings and late afternoons. This view of the area captures a very different scene. An Esso gas station, laundry, and grocery store are visible, as are a few automobiles and trucks. This portion of Elm was the western border of McAdoo Heights, a working-class neighborhood that was platted in 1905 and 1906. Church Street, Cornwallis Drive, and North Buffalo Creek were the other boundaries. William D. McAdoo planned the suburb as an alternative to the textile mill villages nearby, and it appealed to those who did not want to live in company-owned housing. McAdoo Heights was an independent neighborhood with a school, three churches, and numerous stores on State Street when it was annexed by the city in 1923. During the 1930s and 1940s, it was a thriving area, and its bars and pool halls attracted many outsiders, as did a movie theatre that opened in 1949. "The Heights" began a gradual decline after WW II, and, in 1983, a new upscale shopping area called State Street Station reinvigorated the early neighborhood. (Copyright CM.)

Battleground Avenue also underwent significant changes in the 20th century. In 1905, it began at North Greene Street and linked downtown to the Revolutionary War park started by David Schenck in the 1880s. By 1909, it had been extended to Elm, replacing historic Clay Street. The E.D. Golden House at 611 Battleground was typical of the bungalows built along Battleground in the 1920s. Today, few survive on this commercial strip.

By 1950, the Irving Park Delicatessen, owned by Ernest Kahn and Ernest Katz, had become one of Battleground Avenue's best-known attractions. The simple brick building at 1628 Battleground had limited inside seating and a take-out window. In 1962, the Anton brothers purchased the business and added a restaurant in the basement appropriately named Cellar Anton's. The remodeled building is still a popular eating spot.

Long before Battleground became a major thoroughfare, Carolina Hatcheries "Home of Quality Bred Chicks" was built at 1929 Battleground, just east of the future Cornwallis intersection. In the 1955 City Directory, its ad states: "Thousands Hatching Monday and Thursday, Popular Breeds in Laying and Broiler Strains." This business moved in the early 1970s. (Copyright CM.)

As early as the 1920s, new neighborhoods north and west of Irving Park were being developed, but little was done in Kirkwood or Fairfield before WW II. In the 1926 City Directory, the Henry V. Koonts realty firm printed a full-page advertisement for Fairfield. In the late 1950s, this modern Texaco station at 2100 Lawndale Avenue replaced an earlier one called Fairfield Texaco.

This aerial view of Kirkwood was taken on April 31, 1951. Colonial Avenue begins in the lower right corner and extends north, then northwest. Lafayette Avenue begins on the left and runs north to meet Colonial. Liberty and Independence run from east to west. The 1928 City Directory lists C.C. Hudson as president of Kirkwood, Inc., a new subdivision created from David Kirkpatrick's farm, and the William Berry house on Colonial Avenue is included in 1929. The Depression retarded growth in the area. Following WW II, Greensboro experienced a housing shortage, and the W.H. Weaver Construction Company teamed with the Player Construction Company of Fayetteville to build 68 new houses on Colonial and Independence (bottom). Scarce materials plus federal building and selling restrictions equaled small units at an affordable price, about $7,000. (Copyright CM.)

Battleground Avenue was still an undeveloped road with few commercial outlets when a photographer took this picture in June 1962. Standing in front of a service station in the 3100 block and looking east, he captured the intersection that now has Lowe's on the right and Mount Pisgah United Methodist Church on the left (top). Between this location and the Cone-Battleground intersection, a subdivision called Garden Homes was created in the 1950s. Other developments, including Dellwood Park, Westwood, and British Woods, were built on both sides of Battleground as Greensboro grew to the northwest.

Neighborhood changes often included religious and educational buildings, and, in 1947, the first services were held in Beth David Synagogue located on East Lake Drive in Lake Daniel. The Greensboro Conservative Hebrew Congregation, organized by former members of Temple Emanuel in 1944, built Greensboro's second synagogue and used it until 1978. The congregation sold this building and relocated in west Greensboro.

Asheboro Street Baptist Church also moved to a new church in west Greensboro. The congregation organized outside the city in 1899 and moved into this substantial church at 800 Asheboro Street in 1906. As the residential makeup of south Greensboro changed, the church decided to relocate on West Friendly and changed its name to Friendly Avenue Baptist Church.

Bethel A.M.E. Church was organized as Boon's Chapel in 1869, and the congregation built this brick sanctuary on East Friendly Avenue at Regan Street in 1894. The building was razed in 1964 as part of an urban renewal street project, but the congregation rebuilt on the same site. A new education building was completed in 1967 and a sanctuary in 1975.

Another east Greensboro church relocated by moving across the street. St. Stephens United Church of Christ left this sanctuary in 1975 for its new one at 1000 Gorrell Street. The old church was a gathering place for civil rights protesters during the 1960s, and a number of marches originated here. The building has been razed.

The creation of shopping centers also impacted residential growth. On February 7, 1950, Summit Shopping Center (top) opened in the area that had been a WW II army base. Located at Summit and Bessemer, the center originally had seven shops. This was Greensboro's first and North Carolina's second center based on the new concept of parking your car and walking to numerous stores close by. A shopping center in western Greensboro was first proposed in 1953 and construction began in 1954. On August 1, 1957, Blanche Sternberger Benjamin cut the ribbon to open Friendly Shopping Center (bottom). Twenty-five thousand people visited the 24 shops on the first day. This aerial photograph was taken in July 1964. (Copyright CM.)

In November 1952, the congregation of First Baptist Church held its first services in a new $1.5 million complex. By 1950, the church membership of 2,789 required a larger facility, and a groundbreaking ceremony was held that year. The new site was on West Friendly at Mendenhall, and A.C. Woodroof served as architect. This church, the fifth for the congregation, was dedicated on January 1, 1956, when the debt was fully paid. (Copyright CM.)

Julian Price, president of Jefferson Standard Life Insurance Company, planned to build Our Lady of Grace Catholic Church as a memorial to his wife, Ethel Clay Price. Following his death in 1946, his children completed the project. Construction began in 1950, and the church was dedicated in 1952. Located on West Market Street at Chapman, the Tudor Gothic cathedral is one of Greensboro's outstanding buildings.

The city's educational institutions also experienced change after WW II. Greensboro College, chartered as a female school in 1838, began admitting men in 1954. Alumnae were concerned about traditions like May Day with its queen and attendants; this photograph (top) captured the 1945 May Day Court in front of Main Building. At UNCG, a woman's college until 1963, the Daisy Chain was a long-standing tradition. A rope of flowers, made and held by students, was used to line the walk for graduating seniors. This photograph (bottom) was taken on June 3, 1946, in front of Aycock Auditorium. (Copyright CM.)

In 1952, Greensboro completed a public housing project that had been talked about as early as 1937, when a federal bill was enacted to help cities eliminate sub-standard housing. In 1941, voters approved a petition urging the creation of a Greensboro Housing Authority with the power to construct low-rent housing units. An appointed commission, with A.C. Hall as chairman and Ray Warren as executive director, established a ten-year plan that was postponed by WW II. In 1949, the reactivated commission requested that the Public Housing Administration build 800 units in Greensboro. Since housing was segregated at that time, one project would house 400 black families and a second would house 400 white families. Construction of Morningside Homes (top) for blacks and Henry Louis Smith Homes (bottom) for whites began in 1951. The units were occupied in 1952. (Copyright CM.)

Early in the 20th century, a photographer took this scene on North Forbis Street to represent one of Greensboro's popular downtown neighborhoods. In March 1898, the *Greensboro Patriot* had announced the construction of "several handsome dwelling houses" in the area with one to cost $3,000. Forbis Street, which ran from East Washington to Summit Avenue, no longer exists, because in 1954 it was aligned with Church Street. The Victorian houses and the former Catholic church/high school (right) were razed many years ago. The Greensboro pictured here exists only in history, but the site is very much a part of the present and future. In October 1998, the Greensboro Public Library will open where these buildings once stood. It will become part of a cultural block that includes the Greensboro Historical Museum, the YWCA, and the Greensboro Cultural Center. Once again citizens of all ages will see this street as a wonderful place to visit.